IMAGES
of America

New York City Radio

D1600612

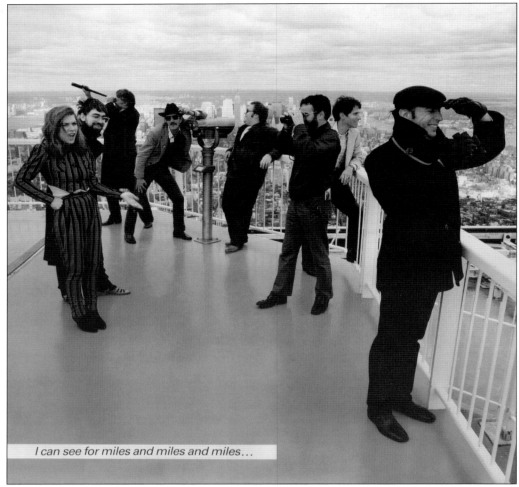

I can see for miles and miles and miles...

Blondie's Debbie Harry and Chris Stein's view from the top of the World Trade Center is blocked by, from left to right, Scott Muni, Dave Herman, Vin Scelsa, Pete Fornatale, Dennis Elsas, and Thom Morrera. This photograph, from one of WNEW-FM's famed calendars, is a bittersweet reminder that New York's most beloved institutions—particularly the ones that seem like they will always, somehow, just *be* there—are often far from permanent. (Courtesy George Meredith.)

ON THE COVER: Long John Nebel is seen here broadcasting his all-night WNBC talk show out of NBC's ultramodern "Monitor" studios (also known as "Radio Central") on the fifth floor of 30 Rockefeller Plaza. Nebel, whose real name was John Zimmerman, started his all-night career at WOR in the mid-1950s, developing a fanatical following for his discussions and dissertations on UFOs, conspiracy theories, alternative medicines, and the like. In 1972, Nebel married and promptly named as his cohost former pin-up model Candy Jones, who famously claimed she had been a victim of CIA mind-control experiments. Was she? The answer is unknown, but it sure made for fascinating and fun radio—and the model for the long-running, syndicated *Coast to Coast* AM, currently hosted by George Noory and airing on WOR. (Courtesy Peter Kanze.)

IMAGES
of America

NEW YORK CITY RADIO

Alec Cumming and Peter Kanze

ARCADIA
PUBLISHING

Published by Arcadia Publishing
Charleston, South Carolina

Printed in the United States of America

Library of Congress Control Number: 2012944700

For all general information, please contact Arcadia Publishing:
Telephone 843-853-2070
Fax 843-853-0044
E-mail sales@arcadiapublishing.com
For customer service and orders:
Toll-Free 1-888-313-2665

Visit us on the Internet at www.arcadiapublishing.com

*Dedicated to Kemosabe No. 1, "Big" Dan Ingram, whose talent and
humor is as big and exciting as the city he loves to speak to*

CONTENTS

ACKNOWLEDGMENTS

All images used in this book come from Peter Kanze's personal collection, unless otherwise noted.

A secondary resource of images, however, deserves special mention: the Library of American Broadcasting's unparalleled repository of radio and television history at College Park at the University of Maryland. This book was helped immeasurably by Michael Henry's unflagging zeal in helping us find rare, extraordinary New York radio photography for this book; we are greatly indebted to him and to the entire hardworking and generous Library of American Broadcasting staff.

Additionally, a tremendous thanks is due to the following people: Susan Albrecht, Maria Alma, Marty Brooks, Stan Brooks, Mark Buniak, Wayne Cabot, Mick Cantarella, Tracy Carmen, Jim Clavin, Jennifer S. Comins, Joe Conzo, Julia Cumming, Ted David, Phil Dejean, Johnny Donovan, Ricot Dupuy, Zen Eidel, Dennis Elsas, Johnny Famolari, Bob Fass, Peter Ferraro, Ken Freedman, Scott Fybush, Meg Griffin, Martin Hardee, Jim Hawkins, Ben Heller, Dave Herman, Felix Hernandez, Debi Jackson, Bill Jaker, Jim Kerr, Mitch Lebe, Ron Marzlock, Elizabeth MacLeod, George Meredith, Carol Miller, Spencer Morash, Paco Navarro, Joe Pardavila, John Porcaro, Mary Anne Powell, Tom Ray, J.R. Rost, Gary Russell, Ed Salamon, Jim Santo, Henry Sapoznik, Phil Schaap, Marcia Segal, Scott Shannon, Janeen Shaitelman, Ron Simon, Valerie Smaldone, Allan Sniffen, Herb Squire, John von Soosten, Pat St. John, Rich and Lisa Stewart, Don Swaim, Bernie Wagenblast, and Jessica Wolfson.

And last but certainly not least, many, many thanks go to the fine crew of professionals at Arcadia, especially to our patient, long-suffering, and never-say-die editor Caitrin Cunningham. Thank you for believing in us, Caitrin, and helping us make this book a reality.

INTRODUCTION

At the northeast corner of Fiftieth Street and Sixth Avenue in Manhattan, you will see the world-famous Radio City Music Hall, home of the Rockettes and the dancing Santas as well as blockbuster movies and award shows. But look across the street, to the southeast corner, and you will find a building that the grand hall named itself after and wanted to bask in the reflected glory of. That building, the one everyone now calls "30 Rock," is a still very functioning temple of American broadcasting nerve center that used to be simply known as Radio City. More than any other building in the world, you are seeing a place designed to be the home base of for an entire medium: radio. That building could be in no other place than New York City—the home base of American radio.

"If you can make it here," the song states, "you'll make it anywhere." And indeed, New York City was (and still is) the number one place for talented, ambitious radio people to come to, make their names in, and go for the gold. So many of New York's radio notables—Arthur Godfrey, Don Imus, Rush Limbaugh, Hal Jackson, Bob and Ray, Jack Sterling, Edward R. Murrow, Jim Kerr, and others—pulled up stakes and came to the Big Apple from out of town and gave it their all when the red "On-Air" light came on. Getting a radio gig in New York City was, and still is, like getting an invite to join the New York Yankees. You just can't say no. New York is the big time. If you are No. 1 in New York, that usually means you are No. 1 in the nation.

New York City, America's biggest town, not only has had dozens and dozens of local stations over the years; we are also the nerve center for American radio and home base for the big four: NBC (Red), ABC (Blue), CBS, and Mutual. Yes, Mutual had a lot of shows produced out of town, and Chicago was a big network center—especially for radio soap operas—and yes, Los Angeles became the main home for big-time, star-studded radio once AT&T established a direct network-quality line to Los Angeles.

But New York really *was* America's Radio City. That particular name is more than a little faded now; in this new media-driven world, moving forward at a bewildering pace, the word *radio* can appear kind of quaint, almost an afterthought. Yet the melting-pot, striving, entrepreneurial nature of our city continues to be clearly reflected in our local and national airwaves and now through the Internet. The world of news and entertainment continues to radiate forth from our city's relentless thinkers, doers, and characters.

If you grew up in the metropolitan New York City area and were born before 1990, chances are you have strong memories of growing up listening to the radio. Maybe you can remember getting ready for school while listening to Scott Shannon and the Z Morning Zoo or perhaps Dave Herman, Ken Webb, or Jay Thomas. You may have caught "morning mayor" Harry Harrison on WCBS-FM. Or maybe you remember Harrison from his WABC days, alongside Cousin Brucie and Dan Ingram. By chance, can you go even further back than that and remember Harry from WMCA, one of the original "Good Guys?" Perhaps you can recall Alan Freed and Jocko Henderson or even Fred Allen and *Let's Pretend*.

New York's radio history has a lot to do with New York's history. It is a cosmopolitan, fast-moving medium for a cosmopolitan, fast-moving city. Our town has long been a beacon that invites those people of the world with big dreams—dreams of freedom, of ambition, of safety, of chance-taking—to come here and make your claim. But you are going to have to be the best at what you do, or else, this is not the city for you.

There is something special, something different, about radio, about how it works with our memories and imaginations. Once television took radio's place as the electronic hearth (at about the same time of the rise of the transistor), radio listening became a much more of a solitary activity. So, when a certain kind of New York listener hears or somehow thinks back on a name like an Alison Steele, Frankie Crocker, Ron Lundy, or Phil Rizzuto, a flood of personalized sounds and memories and thoughts come back. These men and women got into our heads and, often, our souls. And they did not sound like—god bless them—they were from the Midwest, the South, or countries far away (well, Red Barber did have a drawl.) These were New Yorkers we were hearing, and like us, they were fast, funny, smart, and ambitious. And in different ways to different communities at different times, they owned the city. Just think of the disembodied radio voice—seen as just a pair of lips cooing into a microphone—of the female deejay in Walter Hill's *The Warriors*. She is a not just a narrator and troublemaker—she is a virtual goddess, an empress of the New York City night.

Likewise, New York's radio scene is a lot like New York, filled with hardworking dreamers. And perhaps the telling of their story can begin on October 4, 1899, when Gugliermo Marconi came to New York to demonstrate the newfangled science of wireless. He set up a crude Morse code transmitter on a yacht hired by the *New York Herald* so the results of that year's America's Cup race could be instantaneously transmitted back to the paper's newsroom. The news could be spread far and wide, now that it was able to be transmitted via a new form of media—an electronic media (like telegraphy) that was sent through "the ether" (unlike telegraphy). What miracles!

Putting together a book called *New York City Radio* for Arcadia Publishing's Image of America series is a particular challenge because, well, there is so much of it, and so much of it was great, amazing, or worthy of note for one reason or another. It is a task not unlike doing a seventh-grade report on World War II. No matter how hard one tries, important things are going to be left out.

If there is sufficient interest, perhaps this book will become just the first volume in a series of books about New York radio. Basically, we have tried here to present a modest primer of a historical visual record that makes a case for our city, not only as a home for local, community-based broadcasters, but also as an proud industry town, where national and international radio was and continued to be crafted and perfected. Yes, we know there are many stations, personalities, and behind-the-scenes people that deserve mention in a book called *New York City Radio*; if you have ideas—or even better, actual pictures—please get in touch with us!

One

MAGIC IN THE AIR

Dr. Lee DeForest was an important inventor, a brilliant publicist, and one of the world's first broadcasters. Pictured here, he transmits operatic selections from his laboratory near Grand Central Station, "clearly heard at the Metropolitan Life Building over a mile away and at the inventor's Newark, N.J. station, as well as by some hundred or more amateurs within a 20 mile range," according to the May 1910 issue of *Modern Electrics*.

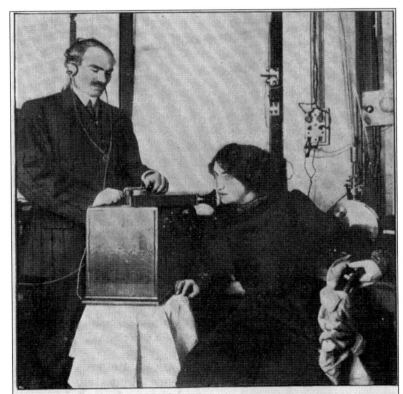

Mme. Mazarin, noted French soprano singing a selection from "Carmen" over the De Forest wireless telephone in New York City in 1909

Vivacious twins Rosetta and Vivian Duncan, stars of Fred Stone's Broadway smash musical *Tip Top*, were the featured performers for what was called the "first radio vaudeville program." It was broadcast by DeForest engineer Bob Gowan from his home in Ossining, New York, on Sunday night, March 13, 1921. Although Pittsburgh's KDKA had famously started a few months previously, most efforts of this kind were still quite novel and considered in the realm of amateur radio; the call letters for Gowan's station (2XX) hark back to the pre-commercial radio era. Clear reception reports were received not only from DeForest's station in High Bridge in the Bronx, but also from Connecticut, Ohio, Arkansas, Illinois, and Washington, DC. This would not be the last time talent from the Great White Way made it onto New York's (and America's) radio airwaves. There was indeed magic in the air.

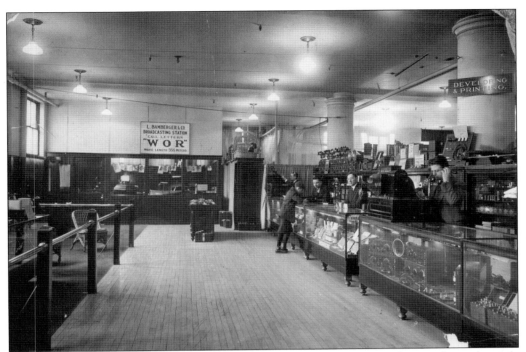

Fred Allen once famously called radio "furniture that talks." Appropriately enough, in the early 1920s, Newark's L. Bamberger & Co. department store started to sell radio sets from its furniture department. But at some point, it was realized that some kind of aural content would need to be broadcast to demonstrate the radios for dubious consumers. From such modest circumstances, station WOR was born; a radio-furniture department's project that is still on the air today, over 90 years later. Chief engineer J.R. Poppele (at telephone, right) introduced records in between ringing up sales. Below is a photograph of a family listening to the radio in the early 1920s. The girl tunes in a station as she and her brother eagerly listen on headphones, while mother and father seem to be multitasking, reading while simultaneously half-listening to "the wireless" via the radio's loudspeaker. The brand-new mass medium was being positioned not just as a hobbyist's toy, but now as an essential part of a modern American family's home—an electronic hearth. (Both, courtesy WOR.)

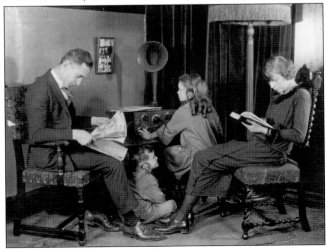

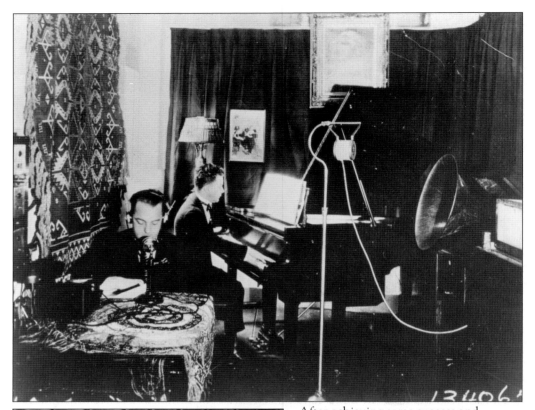

131406

After achieving some success and positive publicity with Pittsburgh's KDKA, the Westinghouse company set three new stations at three of its factories: WBZ (Springfield, Massachusetts), KYW (Chicago), and WJZ, which debuted on October 1, 1921, from the Westinghouse factory in Newark. Seen above is an early broadcast from WJZ's first studio with Westinghouse engineer and announcer Joe Watts at left and main announcer Tommy Cowan at the piano. At left, "first radio girl" Vaughn DeLeath can be seen demonstrating the brand-new, microphone-friendly art of "crooning;" that is, singing in a soft enough manner as to not over modulate the delicate machinery of the radio equipment of the day. Crooning became the predominant pop vocal sound of the era, and Rudy Vallée, Russ Columbo, and Bing Crosby would go on to make the style into an art form. (Both, courtesy Library of American Broadcasting.)

As per the mysterious fashion of the day, WJZ's Tommy Cowan did not use his real name on the air; rather, he used the initials "ACN" (A for announcer, C for Cowan, N for Newark). This method was favored by management, who did not want their announcers to become more demanding due to their increasing fame. Cowan indeed became one of New York radio's earliest stars. He is seen here with movie actress (and William Randolph Hearst mistress) Marion Davies. WJZ, as well as its brand-new big-city competitor WEAF, were becoming magnets for the era's stars of stage, screen, and politics. (Courtesy Library of American Broadcasting.)

One day, legendary WJZ announcer Norman Brokenshire (initially only identified on-air by the initials AON) ran out of copy while he was on the air and had to ad-lib to fill the time; after running out of things to say, he ran to the window, stuck the mike outside, and announced, "Ladies and Gentlemen, the sounds of New York!" Norman's 1954 autobiography was surprisingly frank about the toll his alcoholism took on his career, but he was a survivor, working well into the 1950s.

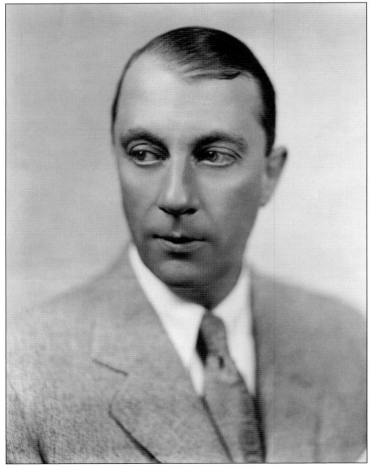

For the 1923 World Series with the New York Yankees battling the Giants, green-behind-the-ears WJZ announcer Graham McNamee was assigned to assist the more experienced sports reporter Grantland Rice in the task of broadcasting the games. But by Game 4, Rice had to hand the mike completely over to McNamee, whose breathless, gee-whiz color commentary started to attract extraordinary attention. McNamee became the era's preeminent sportscaster, even if his sports know-how was not the deepest. (Courtesy Library of American Broadcasting.)

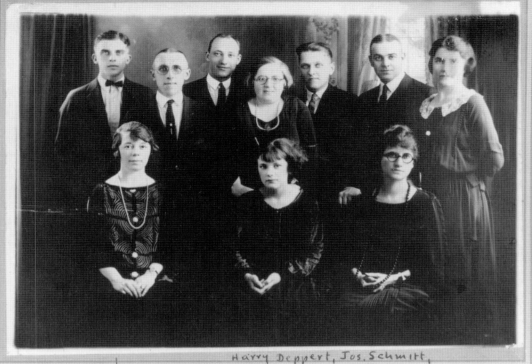

First Staff of WHN February 1922

Harry Deppert, Jos. Schmitt,

TOP ROW: Martha Klaatschken, Wm Boetcher, Dr. Alafberg, Madelyn Hack

SEATED: Louise V. Senger, Madeline Jonelle, Kathryn Chute

This is the adventurous Ridgewood, Queens crew that signed WHN on the air in March 1922, debuting with a whopping 15-watt transmitter. In the second row are director of programs Harry Deppert (second from left) and chief operator William Boettcher (third from right), surrounded by an unusually large component of female announcers, which was quite unusual for the time. A couple of years later, Nils Thor Granlund, publicity chief for the Loew's Theatres organization, bought the station and began to transform WHN into one of the city's liveliest, jazziest, most showbiz-friendly independents (ie: a station not associated with one of the big broadcasting companies)—a story well-documented in his jaunty 1954 memoir *Blondes, Brunettes, and Bullets*. By the time WHN went off the air in 1987, it was the oldest station continuously licensed in the boroughs of New York.

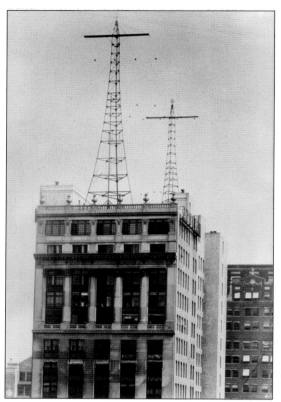

WJZ moved into the city from Newark in 1923, and its antennas were located on the roof of the Aeolian Building, 29 West Forty-second Street in Manhattan; the well-kept studios themselves were located on the sixth floor. Edwin Armstrong, pictured below, a young radio engineer hired by RCA to make sure WJZ and short-lived sister station WJY had the powerful signals it needed, was apparently fearless about the climbing-radio-towers part of his job. One day, he decided to have himself photographed climbing to the top of the antennas in order to impress a young woman he had become infatuated with, David Sarnoff's secretary Marion MacInnis. Sarnoff was infuriated by the flagrant breaking of rules and fired Armstrong immediately, but Marion soon became Armstrong's wife. This would not turn out to be the last run-in between Armstrong and Sarnoff. (Left, courtesy Library of American Broadcasting; below, courtesy Edwin H. Armstrong papers, Rare Book and Manuscript Library, Columbia University Libraries.)

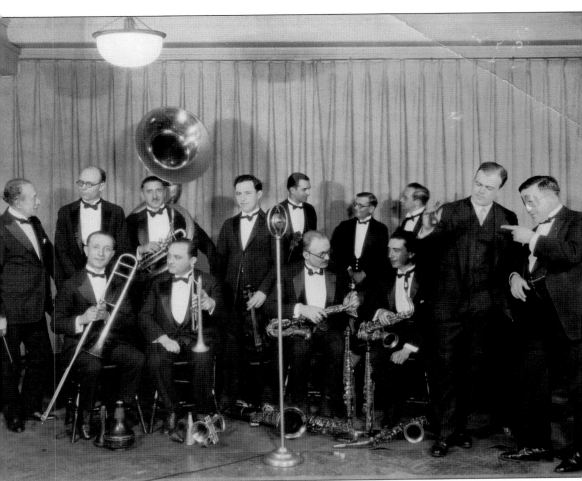

Next to WJZ, AT&T's station WEAF emerged as New York's other powerful, well-equipped, and well-funded broadcasting operation. The station was designed to make a profit by selling its airtime and facilities to advertisers. And it indeed aired what may have been the first-ever radio advertisement in 1922, for an apartment development in Jackson Heights. But "toll broadcasting" (similar to paid public access) proved unwieldy, and soon enough, the station was producing its own entertainment shows like *The Goodtown Silvertone Orchestra*, in which the identity of the show's star vocalist, "The Silver-Masked Tenor," was intriguingly never revealed. Despite the station's high-quality production values and pioneering efforts in intercity (network) hookups, AT&T would get out of the broadcasting business by the fall of 1926. (Courtesy Library of American Broadcasting.)

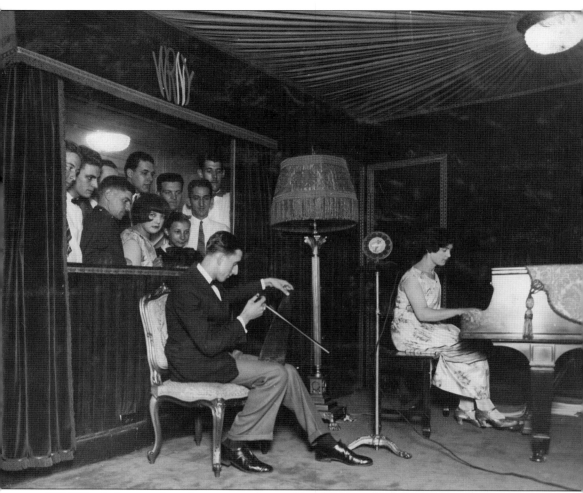

WRNY, while not a long-lasting station, took itself quite seriously; it was founded by Hugo Gernsback, the editor of *Radio News* magazine, whose thoughts about the future of electronics provided the roots of much of the 20th century's most notable science fiction. Pictured here is what was then called a novelty feature, starring one Jerome Lama, who is shown here playing a solo on his favorite instrument, the musical saw. "This versatile and original young man draws music from unheard of sources," breathlessly stated the station's press department, "one of which is nothing less (or more) than an ordinary toy balloon." Note the fascinated studio audience as well as call letters on the funeral-parlor-like studio wall, reminding the artists which station they were on. (Courtesy Library of American Broadcasting.)

A fascinating look at the earliest, haphazard days of radio broadcasting, where distinctions between the various forms of radio—marine, amateur, commercial—were blurred. WRNY stated at the time that "the operator is constantly keeping vigilant watch over marine traffic, and should an S.O.S. be sent out the operator on this watch can instantly shut of the transmitter, announcing into the microphone as he does so, that WRNY is closing down for 'SOS' call." (Courtesy Library of American Broadcasting.)

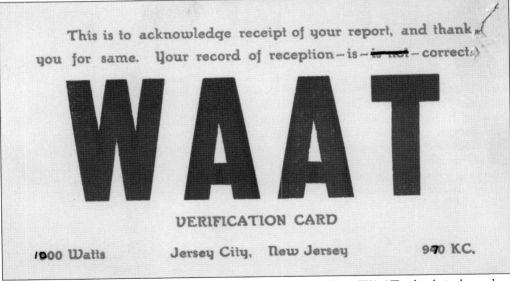

This is to acknowledge receipt of your report, and thank you for same. Your record of reception – is – is not – correct.

WAAT

VERIFICATION CARD

1000 Watts Jersey City, New Jersey 970 KC.

This is a QSL (radio reception verification) card from Jersey City's WAAT, a lively independent station with programming that would eventually rival WNEW's in popularity. Radio frequencies and wattage were rather fluid in the first half of the 20th century; note the thoughtful "corrections" WAAT's engineer made before returning this QSL card in 1941, the year the station upped its power to 1,000 watts and its frequency to 970. (Courtesy Library of American Broadcasting.)

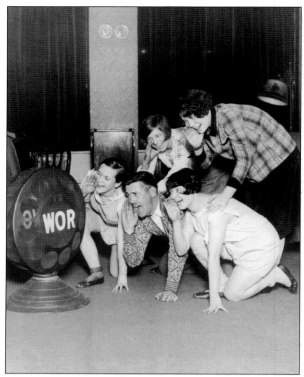

Zany publicity time! WOR's Ed Fitzgerald and a teenage crew give a shout out into a giant microphone in hopes of better distribution. (This microphone still exists in the hands of collectors today.) Ed Fitzgerald, like many at WOR, went on to have a long career at the station as the future star of an erudite morning radio show with his wife, Pegeen.

WOR's dressed-to-impress transmitting station and antennas lived deep in the bleary, bleak heart of the Meadowlands in Kearny, New Jersey. The station wanted to look spectacular, especially at night, to passing New York City–bound commuters; note the spotlights on the lawn and the big "WOR" letters on the antennas themselves. (Courtesy WOR.)

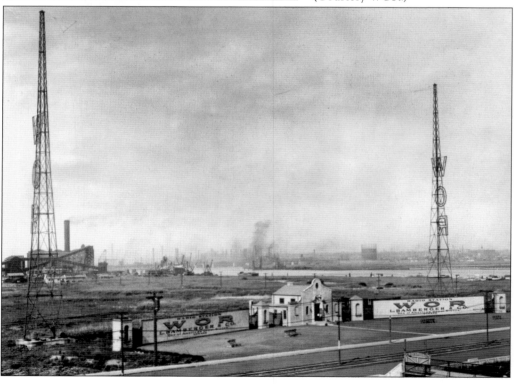

One morning in 1925, WOR's morning exercise show host Bernarr McFadden came down with laryngitis, and his engineer had to step in to save the day. That engineer, one John B. Gambling, was no physical fitness expert but *was* a natural at ad-libbing behind a microphone. His easygoing, good-natured morning show, *Rambling with Gambling*, would become one of New York City's most long-lasting radio mainstays, staying on the air—with either John B., son John A., or grandson John R.—until 2000. (That year, the youngest Gambling rambled over to WABC but returned to WOR in 2008.) But there was more than one family legacy at WOR. Below, John B. hands a commemorative microphone to Alfred W. McCann Jr., whose father had started the station's *Pure Food Hour*, a pioneering show that advocated safer food products and better nutrition. Alfred Sr. passed away in 1931, and Alfred Jr. took over. (Below, courtesy Library of American Broadcasting.)

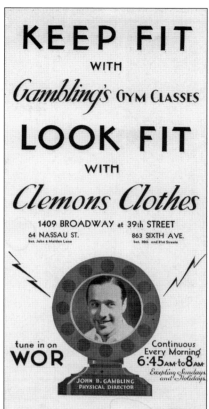

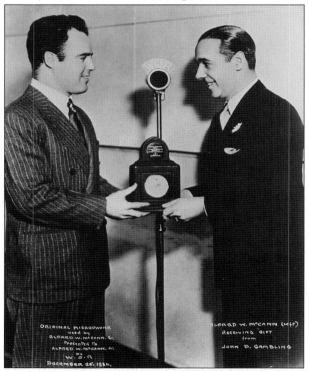

ORIGINAL MICROPHONE
used by
ALFRED W. McCANN. Sr.
Presented to
ALFRED W. McCANN. Jr.
by
W. O. R.
December 26, 1934.

ALFRED W. McCANN (left)
RECEIVING GIFT
from
JOHN B. GAMBLING

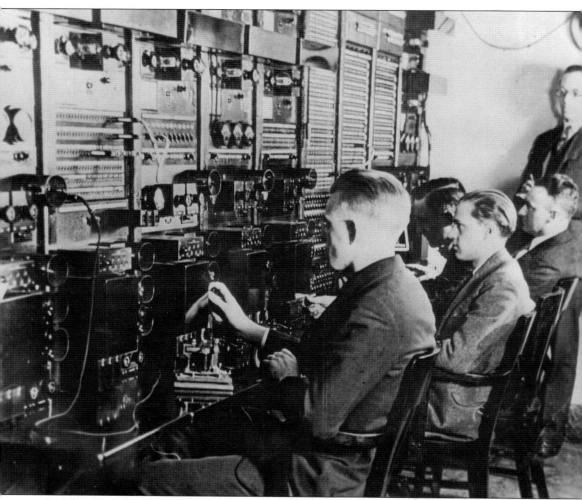

Live from New York, national radio begins! Actually, radio stations from different cities across the country had been connecting themselves to each other as early as 1923. AT&T, the owner of WEAF, was particularly strong at network radio due to its superior transmission lines and equipment. WJZ, run by David Sarnoff's Radio Corporation of America, had a harder time connecting to distant stations, using less-than-ideal Western Union telegraph lines. But by 1926, when AT&T exited the broadcasting business, the two loosely organized "networks" became the tightly run Red and Blue Networks of the brand-new National Broadcasting Company. Pictured here is Sarnoff's chief engineer O.B. Hanson giving the signal at AT&T's Long Distance Building at 32 Sixth Avenue on November 15, 1926, to put NBC on the air. To this day, New York City is America's nerve center for network broadcasting activity. (Courtesy Library of American Broadcasting.)

Taking it to the streets! A valiant WOR crew, batteries, antennas, and Western Electric mike in tow, sets up on a city rooftop. "Remotes" were yet another way the more adventurous, competitive, and technologically savvy stations of the era proved their value to the good citizens of New York. (Courtesy WOR.)

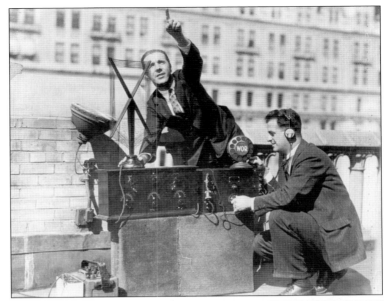

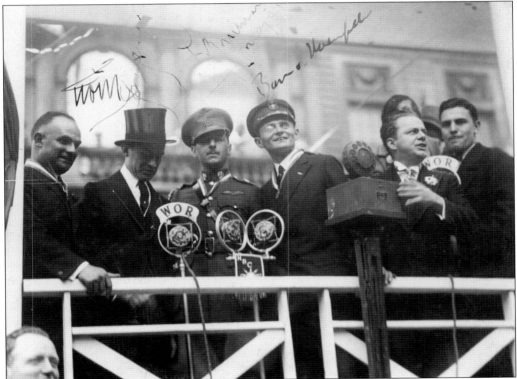

In the 1920s, New York City sure loved its ticker-tape parades, and New York's top radio stations jockeyed for the best microphone location on the dais. This one, on April 25, 1928, was for an aviation achievement little remembered today: the first east-west transatlantic flight by Günther von Hüenfeld and Capt. Hermann Köhl of Germany and Comdr. James Fitzmaurice of Ireland. New York's jaunty, top hat–wearing mayor Jimmy Walker can be seen second from the left.

Paul Whiteman, faintly remembered today but a music superstar of the highest order in the 1920s and 1930s, and his orchestra pose proudly at NBC's plush, new, state-of-the-art studios at 711 Fifth Avenue, engineered by NBC's storied chief engineer O.B. Hanson. The new Art Deco facility (which would prove to be short-lived as NBC's home) was designed to bring the company's different studios and technical control rooms into one central location. A few years earlier, in 1927, Whiteman had commissioned songwriter George Gershwin to compose a symphonic piece for his orchestra; George's piece "Rhapsody In Blue" debuted at the Aeolian Hall in 1927, which at the time was also home to WJZ's studios. Paul was known as "The King of Jazz" at a time when that musical term was more loosely defined. Music historians continue to debate whether his legacy deserves celebration, dismissal, or something in between, but one thing is for certain: Whiteman and his band were by far the most successful act in the music business at the time. (Courtesy Library of American Broadcasting.)

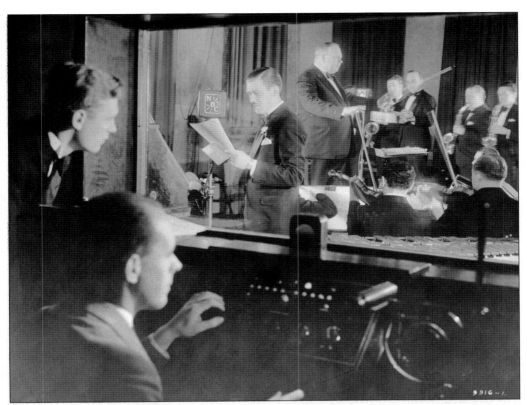

We're on the air! Though almost certainly staged, here is a lovely shot of New York–style network radio production c. 1930, as seen from the control room of one of NBC's 711 Fifth Avenue studios. Dressing appropriately in this era was as much a necessity as good microphone placement, savvy production values, and top-of-the-line, must-hear American entertainment. (Courtesy Library of American Broadcasting.)

Staten Island native Ben Grauer started his career as an announcer for NBC in 1930 at 711 Fifth Avenue and quickly rose through the ranks of professional enunciators. His authoritative and always upbeat delivery helped him receive the nod to be both the official voice of Arturo Toscanini's NBC Orchestra and Walter Winchell's *Jergens Journal*. Here, looking spirited if perhaps in need of a shave, Ben orates in front of a couple of spring-mounted carbon microphones.

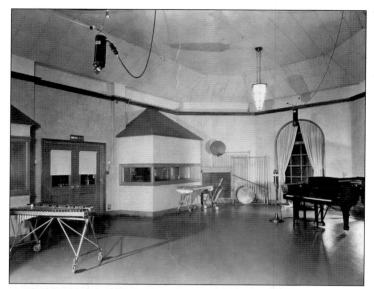

Debuting in 1927, the Columbia Broadcasting System was to become NBC's first real competitor with programs that originally broadcast on either WOR or WABC. The WABC-CBS studios were located on the 17th floor of the Steinway Building in Manhattan in 1929. Note the stationary microphones hung from the ceiling—a miking technique that never really caught on. (Courtesy Library of American Broadcasting.)

On December 18, 1929, William Paley and other assorted swells watched as Miss Radio 1929 cut the ribbon at CBS's brand new headquarters and production center on 485 Madison Avenue, at Fifty-second Street. The structure had been well under construction when Paley signed the lease on 10 floors of the building. The design then had to be quickly adjusted to take the need for several top-of-the-line studios into account. Paley was proud of its location, right in the heart of New York's advertising district. (Courtesy Library of American Broadcasting.)

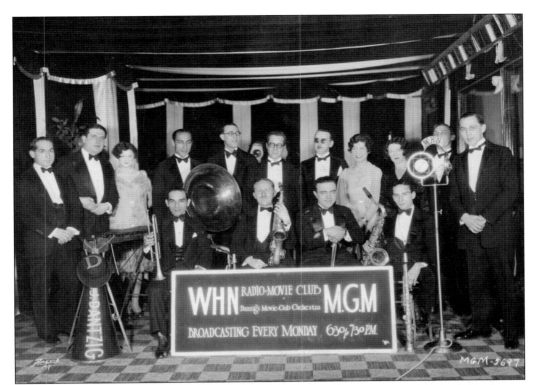

It is "lights, action, glamour!" when Hollywood meets New York City. WHN was owned by Loew's Theatres (which also owned Metro-Goldwyn-Mayer) and presented itself as the station with the closest ties to the burgeoning movie industry. WHN was also particularly strong in presenting the brightest and hottest acts from the city's pop and jazz scene, including Sophie Tucker, Fletcher Henderson, and "Duke Ellington's Jungle Music" straight from the Cotton Club.

Hollywood ingenue Mary Carlisle poses in front of a WHN microphone about 1934. As WHN was tied in with a major movie company, the station's microphones can often be spotted in MGM movies of the era.

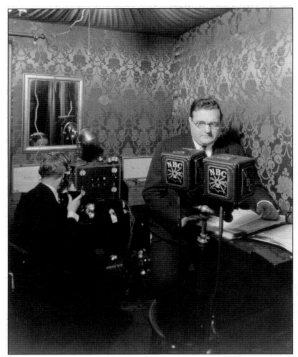

The legendary NBC announcer Milton Cross orates in front of a pair of RCA microphones inside "Box 44" at the old Metropolitan Opera House in the early 1930s. Below, Milton is seen from a different angle, now watching the onstage action as the NBC engineers work with the latest in radio remote technology. The tradition of internationally networked live Saturday afternoon Metropolitan Opera radio broadcasts continues to this day. (Both, courtesy Library of American Broadcasting.)

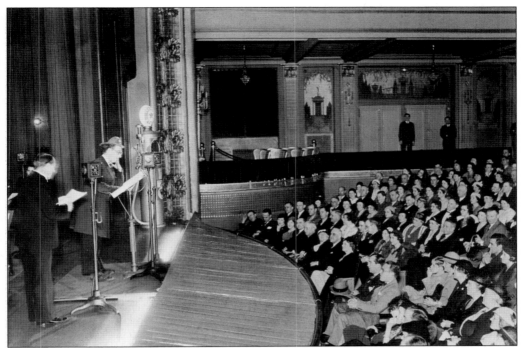

Announcer/sidekick Graham McNamee (left) and comedian Ed Wynn (wearing his "Texaco Fire Chief" hat) perform at the New Amsterdam rooftop theater on Forty-second Street. Ed was a major radio star in the first half of the 1930s and needed a big, excited New York City audience to laugh at his corny jokes and ad-libs; some radio historians believe Ed was responsible for inventing the "studio audience." But not every production at the New Amsterdam theater had an audience one could hear at home. Below is a rare photograph of the theater's legendary "glass curtain," seen during a broadcast of the NBC series *Keys To Happiness*. The curtain was lowered for shows that needed a more controlled audio environment. Audiences could witness the productions but only hear the program through loudspeakers. (Both, courtesy Library of American Broadcasting.)

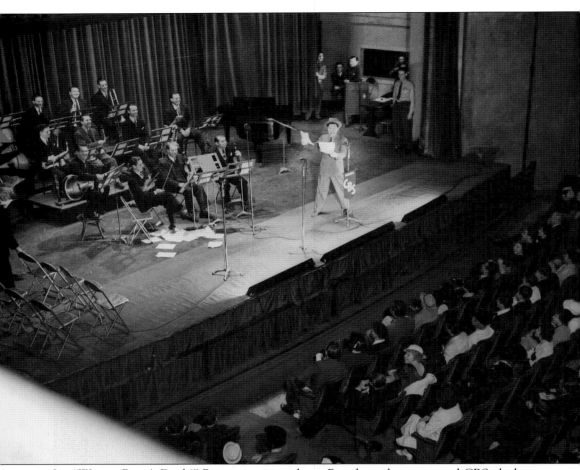

Joe "Wanna Buy A Duck?" Penner is pictured at a Broadway-theater-turned CBS playhouse on West Forty-fifth Street. If one visited a big New York City radio show in the mid-1930s, this is what it looked and felt like—rough-and-tumble, big-time entertainment with a fascinating behind-the-scenes aspect. (Note the flung pages of used jokes at the band's feet.) Penner was what one might call a catchphrase comedian—he was known for punch lines like "Hyuck-hyuck-hyuck" and "You naaaaasss-ty man!"—a style that did not have a particularly long shelf life. Sadly, Penner died in 1941 of a heart attack and is little remembered today. But the 1930s and 1940s were a golden era for New Yorkers and visiting tourists heading to midtown to catch the nation's brightest comedians, players, and personalities performing before the microphone for the millions listening at home. Generally, the admission was free, though tickets for the hottest shows, like those of Rudy Vallée, were often scalped. (Courtesy Library of American Broadcasting.)

Two

A RADIO CITY

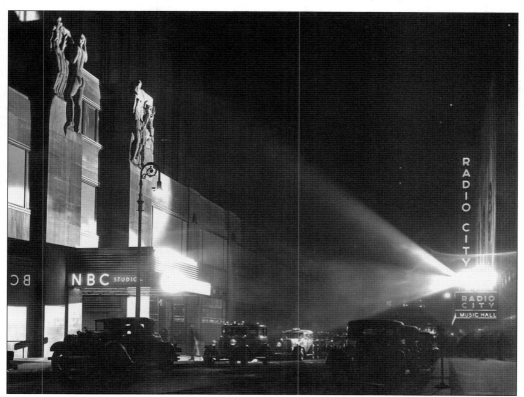

In a wonderful street scene, looking westward towards Sixth Avenue on the north side of Fiftieth Street, the Sixth Avenue "el" can be seen in the distance. To the right is Radio City Music Hall, and to the left is NBC's stunning new home, Radio City. When the Metropolitan Opera House backed out of the ambitious new Rockefeller Center project in 1931, the National Broadcasting Company—which, by the early 1930s, was growing in profitability despite the nationwide economic depression—agreed to be the center's signature tenant. (Courtesy NBC.)

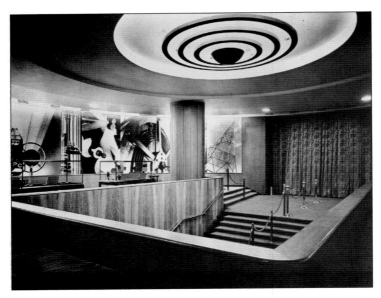

Seen here is Radio City's dazzling mezzanine, where tourists and audiences awaited their trip upstairs to the new broadcasting palace. *Life* magazine photographer Margaret Bourke-White's stunning photographic mural is seen in the background. (Courtesy NBC.)

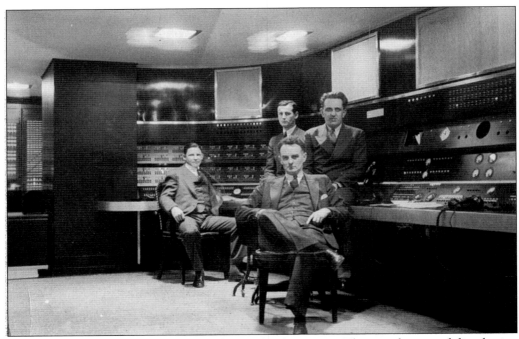

The men of NBC's master control proudly pose for the camera. This was the central distribution point for NBC's Red and Blue Networks, where the outgoing audio from Radio City's array of studios would be sent to a waiting nation. Interestingly, the actual program "switching" from program to program—though preset by the master control engineers—was a task ultimately controlled by each program's announcer. (Courtesy NBC.)

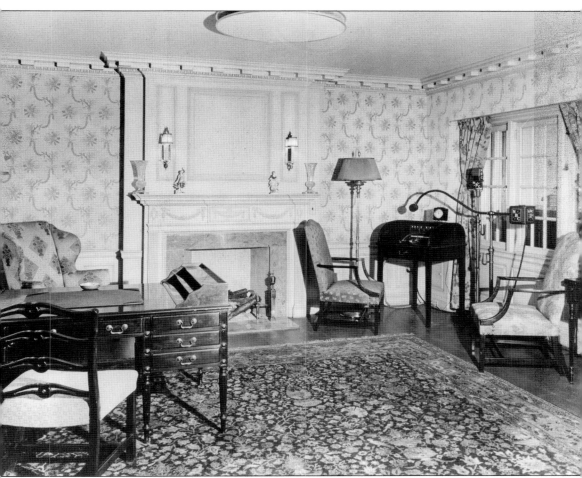

From the start, Radio City (now better known as 30 Rock) was designed to be a temple of broadcasting, a production center for America's leading broadcasting company, and a worthy home for its glamorous stars and widely loved programming. Only at a facility like Radio City would one find Studio 8E, one of the legendary, plushly decorated, cozy "living room studios" on the eighth floor, designed to keep VIPs calm and feeling at home before they spoke to a national audience. Note the desk, also known as the "announcer's delight board." The show's announcer would actually push the button for the NBC chimes himself and then throw the switch to connect the network to its next audio feed! (Courtesy NBC.)

Evelyn Kaye Klein, pictured here, was a Julliard-trained violinist who was the concertmaster of Phil Spitalny's All-Girl Orchestra and, thereby, the star of GE's *Hour Of Charm*, a show produced out of NBC's Studio 8G, an impressive audience studio but small compared to 8H, the one next door. Don Pardo was a regular announcer for the show in its waning years. (Courtesy NBC.)

Seen from inside the rather primitive engineer's booth (primitive by today's audio standards, that is), the cavernous Studio 8H—where NBC's *Saturday Night Live* has been broadcast since 1975—was home to some of the most impressive and challenging broadcasts of its day. The studio was considered one of New York City's true engineering wonders. (Courtesy Library of American Broadcasting.)

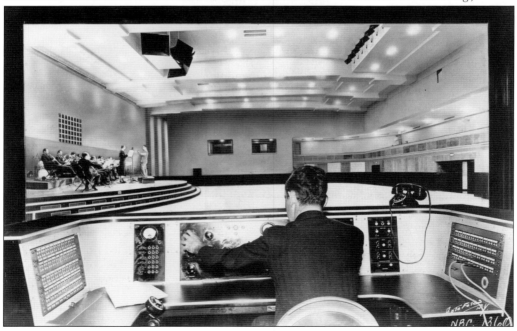

Unquestionably, David Sarnoff, a scrappy, first-generation Jewish immigrant from the Lower East Side, was a technological and entrepreneurial genius that played a hugely important and influential role in the shaping of America's mass media in the 20th century. However, he was not a visionary programmer, nor a "radio guy," at heart. He created the NBC radio networks to both sell radios and make money to fund his next innovation: television. (Courtesy Library of American Broadcasting.)

Sarnoff's rival, CBS's William Paley, was much more of a showman, programming genius, and glamorous figure than NBC's chief of staff. He had a knack for knowing what national audiences wanted to hear and when they wanted to hear it. He wisely expanded CBS's network news programming right before the Second World War and maintained a much more sophisticated relationship to Madison Avenue's advertising community than did his competitors. (Courtesy Library of American Broadcasting.)

This was CBS's marvelous Art Deco lobby at 485 Madison Avenue. The busier radio actors of the era, booked on different shows for competing networks on the same day, often had to make impossibly quick commutes between here and the other studios of the city, especially if the shows' airtimes were close together. Orson Welles often hired ambulances to get himself quickly from radio show to radio show through midtown traffic! (Courtesy Library of American Broadcasting.)

In 1939, CBS, which had its corporate headquarters across the street, bought the building at 49 East Fifty-second Street to move its radio operations, except for the main network newsroom. Architects Fellheimer & Wagner extensively renovated and carved up the building into seven studios, including one that could accommodate audiences of 300 as well as symphony orchestras. Arthur Godfrey broadcast from Studio 21 in this building, which also housed his main office. (Courtesy Library of American Broadcasting.)

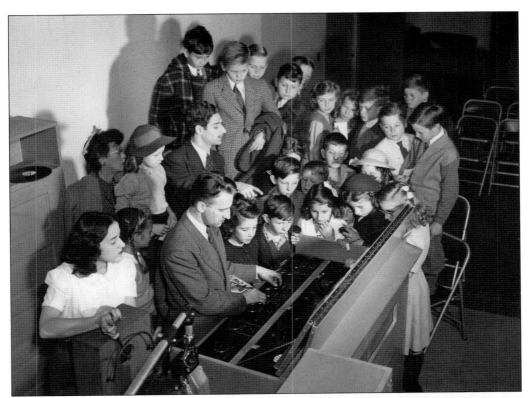

A CBS engineer demonstrates the science behind the magic of radio—and prerecorded sound effects—to fascinated schoolchildren. (Courtesy Library of American Broadcasting.)

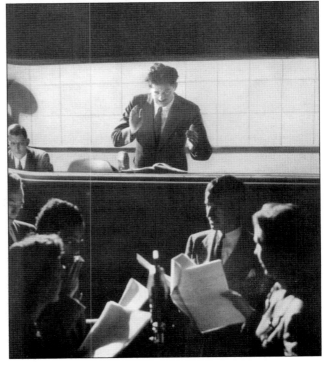

One of radio's most acclaimed creative geniuses, Norman Corwin was another out-of-towner who made his way to New York City, starting out in 1936 at WQXR—the city's new and ambitious classical music-centered outlet. By 1938, he was working for CBS, creating smart, brilliantly produced, and often patriotically stirring radio dramas. Here, he directs an ensemble from the control room. (Courtesy Library of American Broadcasting.)

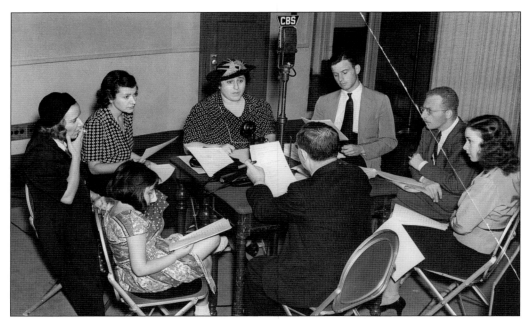

Pictured is a table reading for *The Goldbergs*, a show about a Jewish family living in the Bronx, which started at NBC in 1928 and moved to CBS in 1936. Gertrude Berg, the show's writer and star, is at center. Gertrude wrote the show's scripts herself in longhand, often at the main reading room of the New York Public Library on Forty-second Street. The series was both a heartwarming daily drama and an extraordinarily important look at the Jewish immigrant experience that had become so much a part of New York City's story. (Courtesy Library of American Broadcasting.)

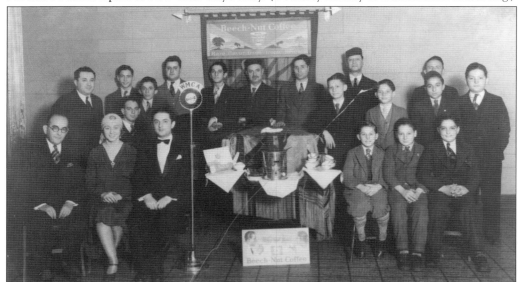

Seen here is the cast of WMCA's *Beech-Nut Coffee Show*, which broadcast partially in Yiddish. The cantor was renowned for synagogue music and Yiddish folk songs, and the pianist was a famous Yiddish theater accompanist/arranger. WMCA frequently featured programming aimed at the city's minority audiences, though perhaps not to the extent of a WEVD or WHOM. (Courtesy Henry Sapoznik Collection, American Folklife Center, Library of Congress.)

SAMUEL GELLARD
PRESIDENT

TELEPHONE
MAIN 4-5716

W·LT·H
BROADCASTING STATION
BROOKLYN EAGLE BUILDING

This symbolic and ambitious letterhead was for WLTH, one of the great Brooklyn radio stations broadcasting to Jewish/Yiddish audiences. (The station also had Manhattan studios at 105 Second Avenue, a location better remembered today as the short-lived home of the legendary Fillmore East.) Victor Packer, pictured below, the hardworking entrepreneur behind much of WLTH's innovative programming for its audiences, pours a glass of pop for Raisele and Shaindele, costars of his *Hammer's Beverage Program*, aimed at the younger set. Though the girls interspersed a healthy amount of Yiddish into their speech, their generation would rely less and less upon the language from the old country than their parents would. (Above, courtesy Library of American Broadcasting; below, courtesy Henry Sapoznik Collection, American Folklife Center, Library of Congress.)

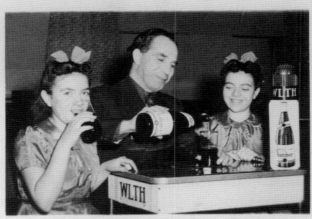

RAISELE and SHAINDELE
VICTOR PACKER
Sponsored by HAMMER'S BEVERAGES
WLTH - 1400 Kilocycles Mon. 9:00 P.M.
Tune in Thurs. 11:45 A.M. for JONAH BINDER

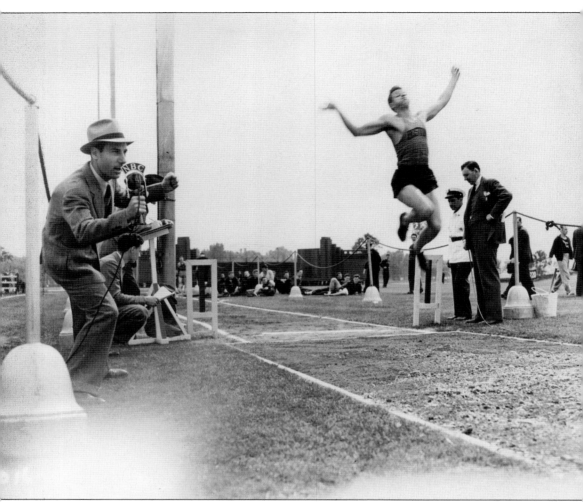

NBC Sports action reporter Bill Stern broadcasts track and field coverage on the scene at the Polo Grounds, normally home to the New York Dodgers. Dating back to the 1921 Georges Carpentier versus. Jack Dempsey fight at Boyle's Thirty Acres in Jersey City, broadcast under the most primitive of conditions by RCA's David Sarnoff and Maj. J. Andrew White (later one of the founders of the CBS Network), radio sports coverage would be a central draw for New York's radio outlets. WOR's Stan Lomax, CBS's Ted Husing, WHN's Sam Taub, and NBC's Clem McCarthy became nearly as famous as the heroes they covered—if not more so—and helped pioneer the art of sportscasting as it is known today. (Courtesy Library of American Broadcasting.)

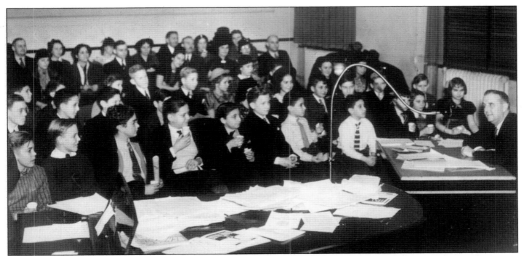

WOR's "Uncle" Don Carney was a beloved children's radio host, but he is mostly (and perhaps unfairly) best remembered for a statement he may or may not have said at a moment he thought his mic was turned off: "There, that oughta hold the little bastards!" The legendary but never recorded sound bite was re-created for one of Kermit Schafer's best-selling bloopers albums, which is a major reason why one may believe they actually heard Carney say that. The truth, alas, is lost in the ether.

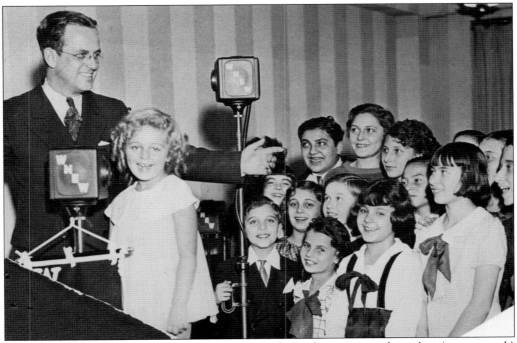

Pictured here is a children's show from the early days of an ambitious new independent (non-network) outlet, WNEW. The station was the result of a merger of two smaller New Jersey–based stations: WAAM in Newark and WODA in Paterson. WNEW did not have the resources and budgets of NBC, CBS, or Mutual but set out from the beginning to present big-time, New York–worthy entertainment programming and information presented in a fun and down-to-earth way.

Bernice "La Mama" Judis, seen above, was WNEW's hardworking station manager and matriarch as well as one of the most well-regarded, closely studied, and frequently imitated executives in broadcasting at the time. She truly loved the medium, keeping a radio is every room of her house; announcers learned to expect calls from Judis at any time of the day or night with a critique or suggestion. She nurtured the career of Martin Block, pictured below, and his *Make Believe Ballroom*, a show that got started accidentally during the sensational Lindbergh baby kidnapping trial of 1935. Block played phonograph records to fill time between the trial's slow-paced news updates; soon, he was playing records throughout the day, which became an extremely profitable practice for the station and a big hit with the fans who got to hear hit records without paying for them—a novelty for the era. (Above, courtesy Library of American Broadcasting.)

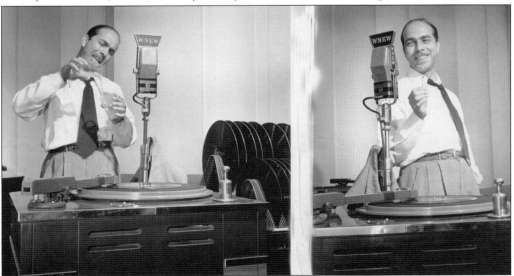

In this photograph, Stan Shaw lights up a cigarette. It is sometime after 2:00 a.m. but before 7:00 a.m., the requests are pouring in, and Stan spins discs all night once again on the station's *Milkman's Matinee*. The all-night show became a hit not only with insomniacs, but also with a growing army of night-shift workers who kept the area's manufacturing plants buzzing around the clock as the nation went to war.

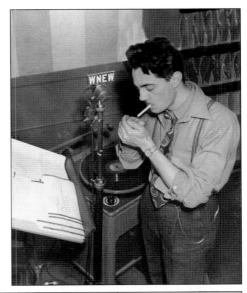

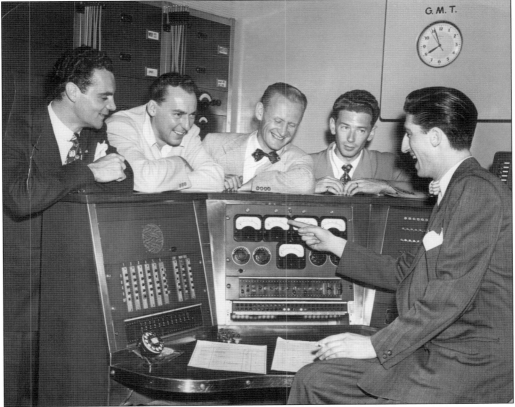

From left to right, big band leaders Chuck Foster, Woody Herman, Sammy Kaye, and Bernie Woods pose cheerily atop a console that Barry Gray finds particularly hilarious. It is 5 to 8 Greenwich Mean Time, which means this photograph was probably taken at 3:56 a.m. Barry's all-night show was a hip hangout for the after-hours Broadway and showbiz crowd. (Courtesy WOR.)

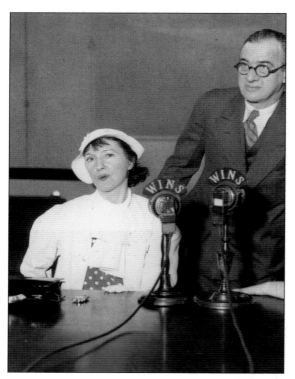

Pictured here is popular author and radio personality Jack Lait with Evelyn Nesbit, "the girl on the red velvet swing," who scandalized the country in the early 1900s. They are promoting her autobiography on WINS, one of the city's lively and competitive independent stations, in December 1940. Author interviews, spiced up with just a touch of promotable "scandal," will become a staple of radio's airwaves that has yet to disappear.

"Good evening Mr. and Mrs. America," barked Walter Winchell, "from border to border and coast to coast and all the ships at sea. Let's go to press." The controversial Winchell, though heard nationally on NBC (and later ABC), was a New Yorker all the way, a hard-bitten Damon Runyon—esque gossip columnist widely feared by celebrities and politicians alike. A close friend with the FBI's J. Edgar Hoover, he was constantly engaged in feuds, including a notable one with WOR's Barry Gray, whom he referred to as "Borey Pink" and a "disc jerk." (Interestingly, the term "disc jockey" itself is attributed by many to Winchell, who may have originated the phrase to describe WNEW's extremely popular Martin Block.)

Three

WARS OF THE WORLD

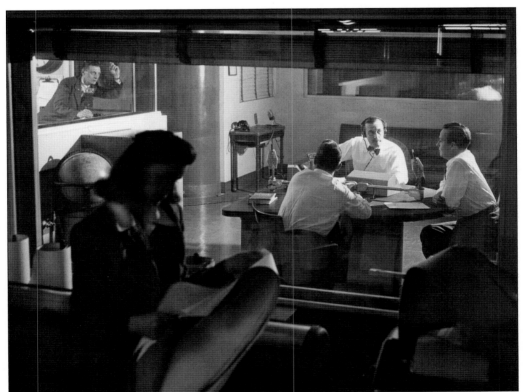

As storm clouds gathered around the world at the end of the 1930s, CBS's ambitious radio news division, based on the 17th floor of 485 Madison Avenue, kicked into first gear, aggressively covering the world news scene with frequent international pickups (delivered via unpredictable shortwave pickups) and heavy-duty news analysis. CBS's publicity machine created electrifying images like this, designed to show national audiences a new level of seriousness (and, perhaps, glamour) for its New York–based broadcast news gathering. (Courtesy Library of American Broadcasting.)

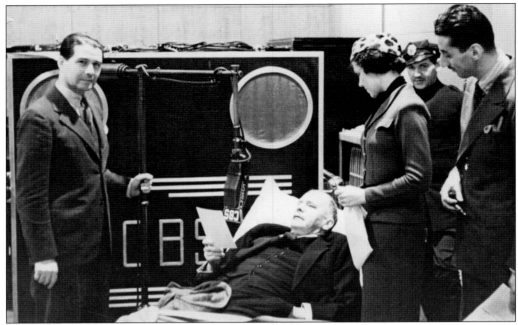

Hans Van Kaltenborn was a CBS news analyst with a knack for combining authoritative-sounding reasoned analysis with rather plain, folksy Americanisms. But it was during the Munich crisis of September 1938, when he actually slept in a cot in his studio at 485 Madison Avenue, that he really acquired national fame. Here, CBS's director of talks Helen Sioussat (standing next to Kaltenborn) and correspondent Robert Trout (right) bemusedly watch the sleepy commentator prepare for another live read. (Courtesy Library of American Broadcasting.)

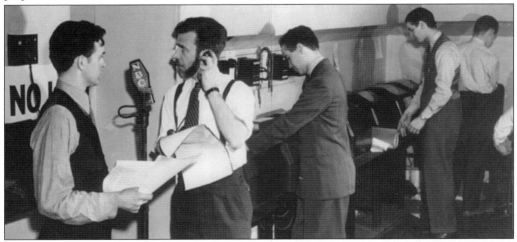

NBC News, based out of the fourth floor of Radio City, sent out this press photograph a week after the attacks at Pearl Harbor. Here, correspondent Robert St. John prepares to interrupt regular programming directly from the newsroom (obviously, the chattering teletype machines were meant to be heard in the background, their sound was well on its way as an indispensable aural cliché for radio news gatherers). Unfortunately for St. John, a decade later he was named as a "communist sympathizer" in the infamous *Red Channels* book, and the network fired him in 1951. (Courtesy NBC.)

NBC's ever-versatile announcer Graham McNamee is seen reporting on the fire that destroyed the cruise liner *Normandie* in February 1942 at Pier 88, the site of what is now the New York passenger ship terminal. Clay Morgan, assistant to the president of NBC, stands behind McNamee, while a news technician carries a "portable" transmitter on his back. Such on-the-scene live reporting was still a novelty at the time. (Courtesy NBC.)

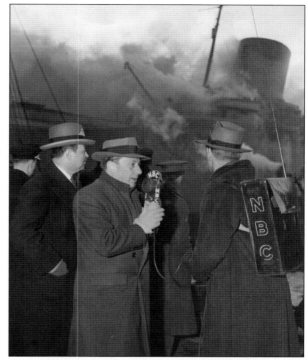

Seen here is a wonderful look at a WOR/Mutual Radio news broadcast in action, from the 1440 Broadway studios. By the time America was fully involved in World War II, all the broadcast networks knew that a strong and promotable commitment to international news coverage was essential to keeping its audience tuned in. (Courtesy WOR.)

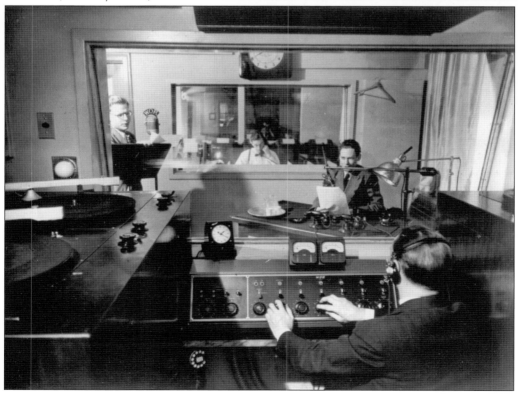

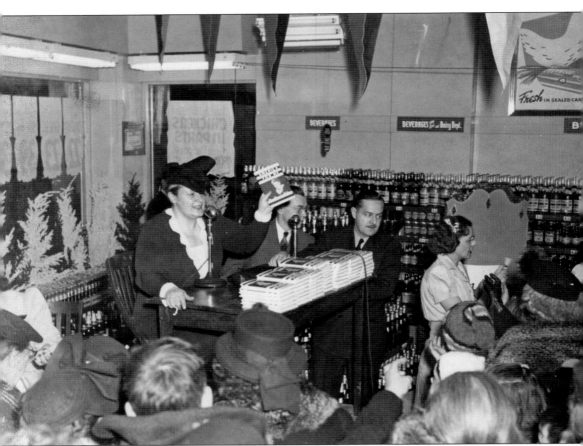

NBC's Mary Margaret McBride hawks one of her many books (here, it is *America For Me*) at a grocery store appearance in Little Neck, Queens on June 8, 1942. Next to Eleanor Roosevelt, McBride was probably the most influential woman in America at the time but—then as now—got little respect in the mainstream radio industry for her extraordinary popular appeal. She had started her radio career at WOR in the mid-1930s as a fictional character named "Martha Deane," dispensing grandmotherly advice to homemakers, but soon abandoned the character to speak to her daytime audience in a more believable, plainspoken, and intelligent manner. By the time of her 15th anniversary broadcast in 1949, the only venue big enough to hold her live audience was a sold-out Yankee Stadium. (Courtesy Library of American Broadcasting.)

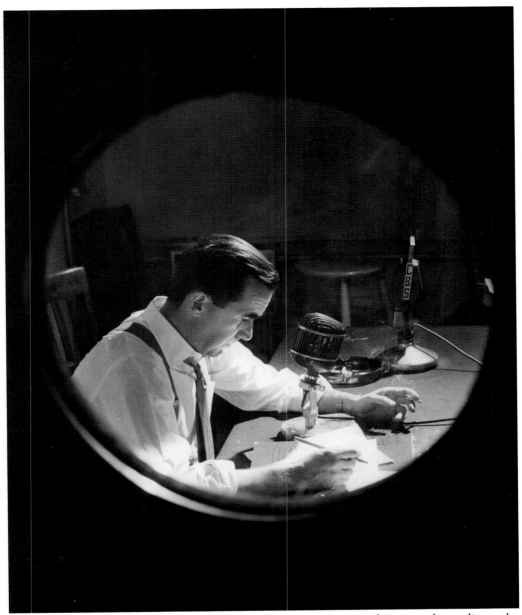

Edward R. Murrow prepares to broadcast news to a waiting America from a smoky studio on the 17th floor of CBS Radio's studio building at 485 Madison Avenue in New York. (Courtesy Library of American Broadcasting.)

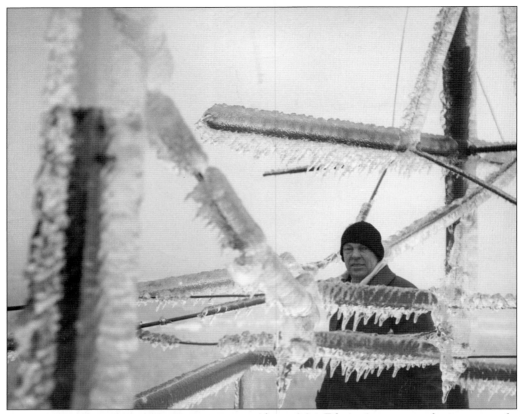

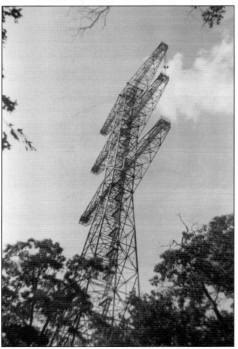

Above, Maj. Edwin Armstrong, the inventor of FM radio, gazes from an icy Alpine, New Jersey, antenna; the dead of winter and treacherous winds would not stop Armstrong from his mission for static-free broadcasting. It is from this antenna, seen at left—which is still in use today, towering high over Exit 2 of Palisades Parkway and visible to David Sarnoff's 52nd-floor office at 30 Rockefeller Plaza, much to his chagrin—that the first FM stations broadcast to the New York City metropolitan area. (Both, courtesy Edwin H. Armstrong papers, Rare Book and Manuscript Library, Columbia University Libraries.)

By 1940, many stations had applied for and received FM radio licenses in the New York market, but few were actually on the air. The industry was keeping a close eye on the technology, but Armstrong's hopes for quick success with the static-free format was hurt by a need for listeners to buy completely new radio sets to hear programming that was not exactly ready for prime time.

Major Armstrong launches WOR's new FM outlet, W71NY, by turning a ceremonial key on a Western Electric board on November 30, 1941. This broadcast was a part of the hopeful launch of the American Network, a service that linked seven Northeastern FM stations together. But America's war, just days away from this inaugural broadcast, would stall the advance of FM—much as it did for television—and the American Network would be dissolved by 1944. (Courtesy Edwin H. Armstrong papers, Rare Book and Manuscript Library, Columbia University Libraries.)

City	Call Letters AM Affiliation	Licensee P.O. Address	Principal Executive in Charge	New Frequency (Channel No.) Reduced Power	Old Frequency Power	Transmitter Location Date Established
MISSOURI						
KANSAS CITY	KMBC-FM KMBC	Midland Broadcasting Co., Pickwick Hotel	Arthur B. Church Karl Koerper	47.9 mc (190) 20 kw	46.5 mc 1.5 kw	Power & Light Bldg. June, 1944
KANSAS CITY	KOZY	Commercial Radio Equipment Co., 406 W. 34th St.	Everett L. Dillard Robert F. Wilhoit	26.2 mc (240) 20 kw	44.9 mc	406 W. 34th St. August 16, 1941
NEW JERSEY						
ALPINE	W2XMN	Maj. Edwin H. Armstrong, 435 E. 52nd St., New York	Maj. Edwin H. Armstrong Perry Robinson	92.9 mc (250) 40 kw		Route 9W, Alpine 1939
NEWARK	W2AAW (CP)	Bremer Broadcasting Corp., 11 Hill St.	Irving R. Rosenhaus	94.1 mc (231) 13.5 kw		West Orange, N.J.
NEW YORK						
BINGHAMTON	WNBF-FM WNBF	Wylie B. Jones Adv. Agency 40 Exchange St.	John C. Clark Cecil D. Mastin	96.5 mc (243) 12.5 kw	43.9 mc 4 kw	Mt. Binghamton August, 1941
NEW YORK CITY	WABC-FM WABC	Columbia Broadcasting System 485 Madison Ave.	William F. Paley Arthur Hull Hayes	46.9 mc (245) 10 kw	46.7 mc 1 kw	500 Fifth Ave. December 4, 1941
NEW YORK CITY	WABF	Metropolitan Television Inc. 654 Madison Ave.	Ira A. Hirschmann L. L. Thompson	48.5 mc (253) 1 kw	47.5 mc	793 Fifth Ave. November 2, 1942
NEW YORK CITY	WBAM WOR	Bamberger Broadcasting Service Inc. 1440 Broadway	Alfred J. McCosker Theodore C. Streibert	96.5 mc (243) 10 kw	47.1 mc 10 kw	444 Madison Ave. September 27, 1940
NEW YORK CITY	WEAF-FM WEAF	National Broadcasting Co. 30 Rockefeller Plaza	Niles Trammell John F. Royal	97.3 mc (247) 7.2 kw	45.1 mc 1 kw	Empire State Bldg. August 8, 1941
NEW YORK CITY	WGHF	Finch Telecommunications Inc.	William G. H. Finch	99.7 mc (259) 13.5 kw		10 E. 40th St. January, 1941
NEW YORK CITY	WGYN	Muzak Radio Broadcasting Station Inc. 70 Pine St.	Painter E. Leiterman Carl J. Schaefer	96.5 mc (243) 12.5 kw	34.7 mc 1 kw	70 Pine St. December 11, 1944
NEW YORK CITY	WHNF WHN	Marcus Loew Booking Agency 1540 Broadway	Loew's Inc. (MGM) Herbert L. Petrey	99.3 mc (257) 20 kw	46.3 mc 20 kw	Cliffside Park, N.J. June 1, 1941
NEW YORK CITY	WNYC-FM WNYC	Municipal Broadcasting System Centre & Chambers Sts.	City of New York	94.5 mc (233) 10 kw	43.9 mc 1 kw	Center & Chambers Sts. September 21, 1943
NEW YORK CITY	WQXQ WQXR	Interstate Broadcasting Co. Inc. 730 Fifth Ave.	N. Y. Times, John V. L. Hogan Elliott M. Sanger	45.9 mc 45.9 mc 11.5 kw	45.9 mc 1 kw	125 E. 42nd St. November 8, 1939
ROCHESTER	WHEC WHEC	WHEC Inc. 40 Franklin St.	Clarence Wheeler Gunnar Wiig	95.5 mc (253) 10 kw	44.7 mc 1 kw	Mt. Road Blvd. February 1, 1940
ROCHESTER	WHFM WHAM	Stromberg-Carlson Co. Stanton Blvd.	Ray H. Manson William Fay	98.9 mc (255) 20 kw	45.1 mc 7 kw	89 East Ave. November 1, 1939
SCHENECTADY	WBCA	Capitol Broadcasting Co. Inc. 408 State St.	Leonard L. Asch H. R. Roduner	104.5 mc (246) 12 kw	44.7 mc 1 kw	New Scotland, N.Y. July 13, 1941
SCHENECTADY	WGFM WGY	General Electric Co. 1 River Road	G. E. Markham Lester H. Halttner	100.7 mc (264) 6 kw	48.5 mc 3 kw	New Scotland, N.Y. February 6, 1940
NORTH CAROLINA						
WINSTON-SALEM	W4XIT WSJS	Gordon Gray P.O. Box 3093	Gordon Gray Harold Essex	97.5 mc (247) 200 kw	44.5 mc 3 kw	Chapman's Peak, N.C. June 1, 1941
OHIO						
COLUMBUS	WELD WENS	RadiOhio Inc. 33 N. High St.	Edgar T. & Richard S. Wolfe J. Richard A. Borell J. Lester H. Nafzger	94.5 mc (235) 20 kw	44.5 mc 3 kw	1811 Parsett Rd. March 19, 1940
PENNSYLVANIA						
PHILADELPHIA	KYW-FM KYW	Westinghouse Radio Stations Inc. 1619 Walnut St.	Westinghouse Electric Co. Lee B. Wailes—Leslie Joy	100.3 mc (262) 10 kw	45.7 mc 10 kw	15th & Spanson Sts. October 5, 1943
PHILADELPHIA	WCAU-FM WCAU	WCAU Broadcasting Co. 1622 Chestnut St.	Dr. Leon Levy Nayda Wood	103.7 mc (274) 10 kw	46.9 mc 10 kw	1616 Walnut St. November 9, 1941
PHILADELPHIA	WFIL-FM WFIL	WFIL Broadcasting Co. Widener Bldg.	Lit Bros. Dept. Store Roger W. Clipp	103.1 mc (276) 20 kw	45.1 mc 10 kw	Widener Bldg. November 16, 1941
PHILADELPHIA	WIBG-FM (CP) WIBG	Seaboard Radio Broadcasting Corp. 1425 Walnut St.	P. F. Harron–Joseph Lang E. D. Clery	97.1 mc (246) 20 kw		Ford Rd. & Edger
PHILADELPHIA	WIP-FM WIP	Pennsylvania Broadcasting Co. 35 S. Ninth St.	Gimbel Bros. Inc. Benedict Gimbel, Jr.	97.9 mc (248) 10 kw	44.9 mc 3 kw	35 S. Ninth St. April 20, 1942
PHILADELPHIA	WPEN-FM WPEN	William Penn Broadcasting Co. 1528 Walnut St.	Philadelphia Bulletin G. Bennett Larson	98.5 mc (253) 20 kw	45.1 mc 3 kw	1123 Walnut St. June 6, 1942
PITTSBURGH	WDKA-FM KDKA	Westinghouse Radio Stations Inc. 820 Grant St.	Westinghouse Electric Co. J. E. Baudino	94.1 mc (231) 5.5 kw	47.5 mc 5 kw	Alfson Park, Pa. April 11, 1941
PITTSBURGH	WMOT WWSW	WWSW Inc. 312 Ward St.	Pittsburgh Post-Gazette Frank R. Smith	94.5 mc (233) 20 kw	44.7 mc 1 kw	341 Rising Main St. August 1, 1941
TENNESSEE						
NASHVILLE	WSM-FM WSM	National Life & Accident Insurance Co. 7th Ave. & Union St.	W. W. Craig Harry Stone	100.1 mc (261) 5.5 kw	46.7 mc 10 kw	Nr. Franklin, Tenn. March 15, 1941
UTAH						
SALT LAKE CITY	KSL-FM (CP) KSL	Radio Service Corp. of Utah 10 S. Main St.	Mormon Church J. Tillman & Telegram E.S kw	100.1 mc (261) 8.5 kw		
WISCONSIN						
MILWAUKEE	WTMJ-FM WTMJ	The Journal Co. 333 W. State St.	Milwaukee Journal Walter J. Damm	93.3 mc (232) 20 kw	44.9 mc 20 kw	Richfield, Wis. February 11, 1941

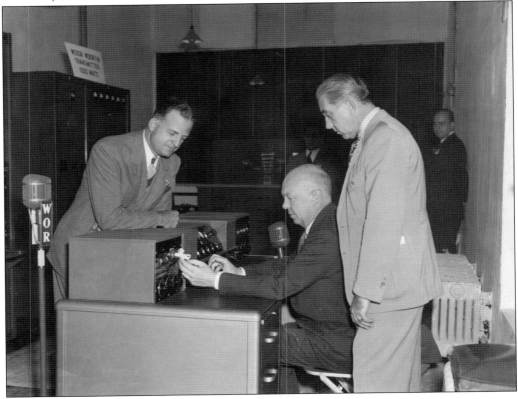

The promising new world of FM broadcasting did create some interesting and ambitious, if short-lived, radio stations. Muzak, the "wired radio" service that was started in 1934 to send energizing and/or relaxing music into offices, elevators, and other public spaces, started by broadcasting its mellow music on WGYN, proving that the "beautiful music on FM" phenomena started far earlier than the 1950s. WGHF, which launched right after the end of World War II, broadcast both regular programming and, on a subcarrier frequency, facsimile tones that would enable listeners to get printed information delivered right into their homes, as long as they had the proper equipment, of course. The intriguing facsimile-via-radio idea had actually been tried previously (on WOR radio during overnights) and would be tried again but would never quite catch on.

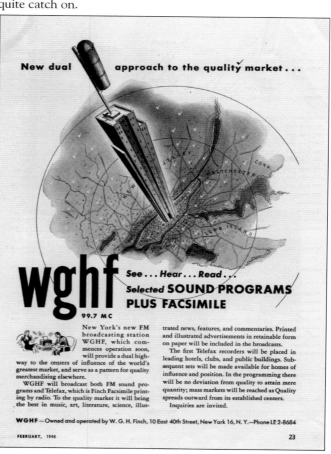

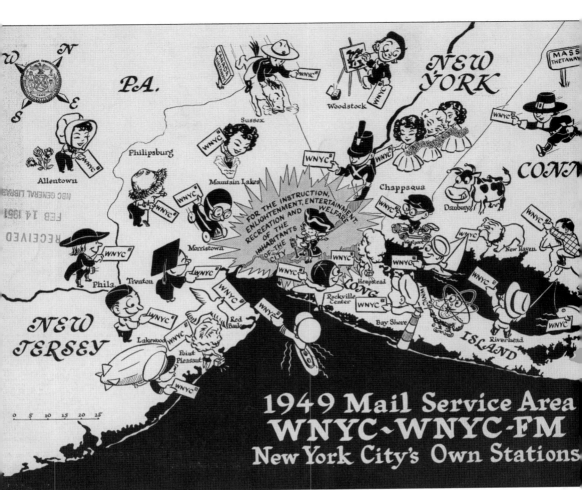

1949 Mail Service Area
WNYC·WNYC-FM
New York City's Own Stations

New York's municipal station was proud of its reach, although to imply that there were regular listeners in, say, Allentown may have been a bit of an exaggeration. WNYC's stolid, civic-minded programming—a far cry from today's glossy, hipster-friendly station—was not too much of an audience grabber either. But WNYC, both AM and FM, has become one of New York's most intelligent, well-staffed, and ambitious stations and enjoys a large, and growing, loyal audience. It is worthy to note that by the time of the printing of this map, Oscar Brand's *Folksong Festival*, which is still on the air today and still hosted by Brand himself, was already at least three years old. (Courtesy Library of American Broadcasting.)

Art Ford, then at WBNX, is pictured here with guest Deanna Bartlett, who appeared on Ford's program *All Thru The Night*. Bartlett was billed as being the youngest female music publisher on Tin Pan Alley in 1941.

By late 1945, the war was over, and WHOM's record librarians cheerfully returned to the business of picking the hits through a record library consisting of 78s and perhaps a few 16-inch transcription records. But no matter how valiantly the station manager tried to present WHOM as mainstream friendly, the station would be forever best known for its foreign-language programming; it later became home for many Spanish-language shows. (Courtesy Library of American Broadcasting.)

In the 1920s, many of the smaller metropolitan-area stations had odd time-sharing arrangements. But well into the 1950s, Newark's WHBI—managed by William Masi (at right)—had an extremely odd one; it broadcast only on Sundays. The studio was located in the Hoyt Brothers commercial warehouse in downtown Newark, New Jersey. (Whenever the elevator stopped at the studio floor, its rumble could be heard on the air.) WHBI shared its frequency with WOV, which would eventually buy out the station. Below is an early publicity still of Danny Stiles, who got his start at WHBI as an elevator operator and would go on to become a rhythm-and-blues and pop standards deejay who would remain on the air for 53 years. (Right, courtesy Library of American Broadcasting; below, courtesy Gary Russell.)

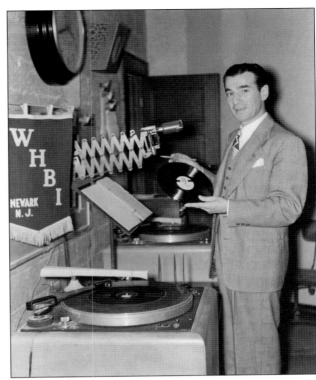

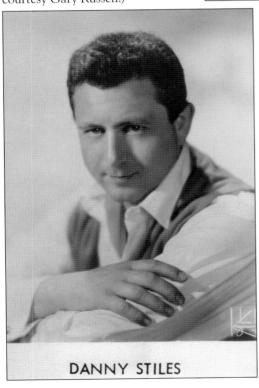

DANNY STILES

Seen here is Peggy Lloyd, WOV's morning hostess on the program *Wake Up New York*. Lloyd, married to actor Norman Lloyd, had been a regular in Orson Welles's *Mercury Theater*; she gave up the morning shift in 1947 for "more housewifely duties" and was replaced by deejay "Bill" Williams, who was just coming off a three-year introductory stint at WNEW and would later return to that station under the better-remembered moniker of "William B. Williams." (Courtesy Library of American Broadcasting.)

WBYN announcer Art Raymond—often called "the dean of Yiddish Radio"—also hosted the Latin music-themed *Tico Tico Time*, in which he danced while reciting the steps over the air. The same stations that played Jewish programming also often programmed Latin music, and the two genres crossed over more frequently than one might suppose. Raymond also did this show on WVNJ but may be best remembered for his long-running hosting duties on WEVD's morning show *Raisins and Almonds*. (Courtesy Library of American Broadcasting.)

Arthur Godfrey hosts the radio version of his show *Talent Scouts*. Godfrey was a tremendously popular morning show host, originally from WJSV in Washington, DC. Arthur frequently made fun of his sponsors and had an everyman appeal—that is, of course, until his ill-thought-out on-air firing of Julius LaRosa on October 13, 1953. Of course, Godfrey's career lasted for a good while longer, and his CBS daily radio show finally signed off in 1972. But his nice-guy act had taken a bad hit. (Courtesy Library of American Broadcasting.)

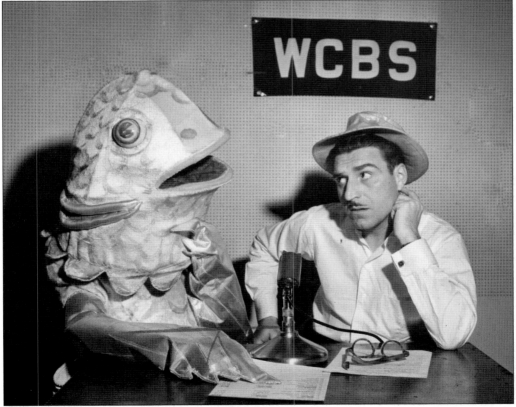

Jack Sterling, WCBS's morning guy, was known for his tips on fishing sites, which may help explain this 1949 publicity shot. While not really comparable to today's "Morning Zoo" level of wackiness, Sterling had the perfect, light-hearted touch for morning-show audiences of the 1950s and early 1960s. (Courtesy Library of American Broadcasting.)

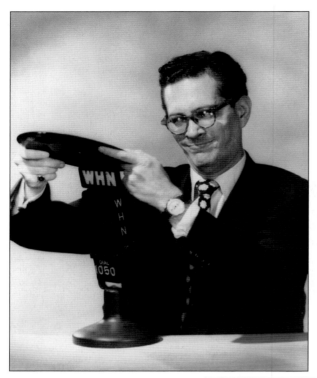

Robert Q. Lewis was plain old Bob Lewis until one momentous day when he decided to throw in a "Q" as a middle initial. "I guess it was the luckiest thing I ever did," he shrugged. Lewis was a relaxed personality who navigated the uncertain waters of postwar radio well, often playing the kind of offbeat records on his morning show at WMGM that Dr. Demento later became well known for.

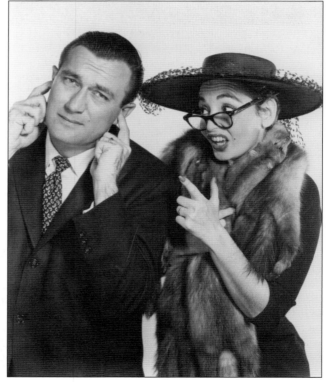

Ted Brown and the Redhead replaced Lewis at WMGM once he left for greener pastures at WCBS in 1949. "The Redhead," seen here, was Brown's real-life wife, Rhoda. Later on, actress Sylvia Miles became Ted's nest "redhead" and second wife as well, memorably arguing over alimony near the end of *that* marriage. The pair were outrageous for their time, an interesting contrast to the more elegant and polite married radio teams of the era.

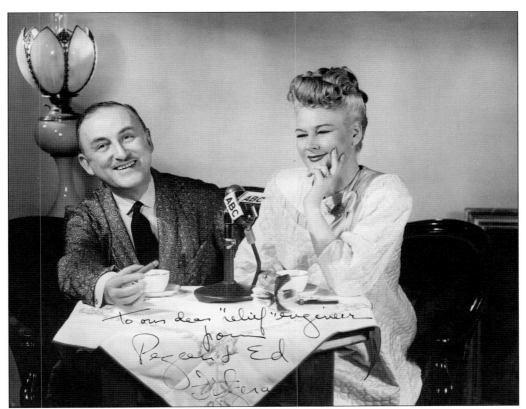

WABC'S Ed Fitzgerald and his wife, Pegeen, are seen here starting their day glamorously—long before the station's Musicradio 77 era—from their elegant 16th-floor apartment high above Central Park West. They were arguably the originators of the husband-and-wife morning show radio genre, a style that may now seem like a quaint relic of a different time but not unlike the still successful *Regis and Kathie Lee* brand of morning pleasantness.

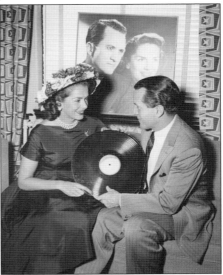

They were known as "Mr. Brains and Mrs. Beauty." Jinx Falkenberg McCrary, a former model and actress well known for her magazine covers and USO tours, is seen here holding a transcription disc with her cohost and husband, Tex McCrary; perhaps they are promoting the syndicated version of their WEAF show. The McCrary's show was a bit more high minded than the other husband and wife shows of the era, possibly due in part to Tex's background as a journalist. (Courtesy Library of American Broadcasting.)

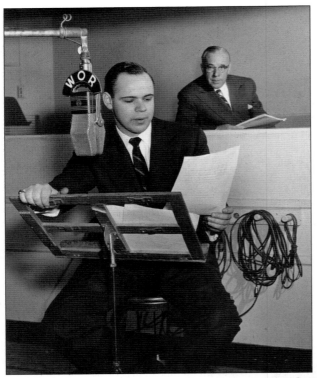

A passing of the torch of sorts takes place on the air as a father watches his son try out some copy. After substituting for his dad, John B., throughout the 1950s, John A. Gambling fully took over the reigns of WOR's *Rambling with Gambling* in 1959. Below are, from left to right, John B., John R. and John A. Gambling in the mid-1950s. Although it is unlikely John B. planned on starting a family dynasty in the 1920s, he certainly did—an easygoing one at least—and John R. proudly continues the tradition on New York's airwaves today. (Both, courtesy Library of American Broadcasting.)

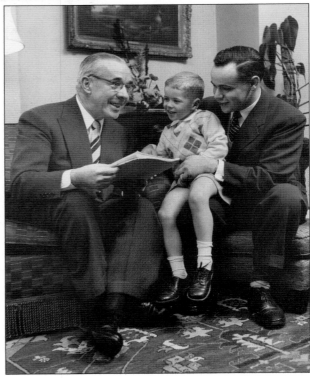

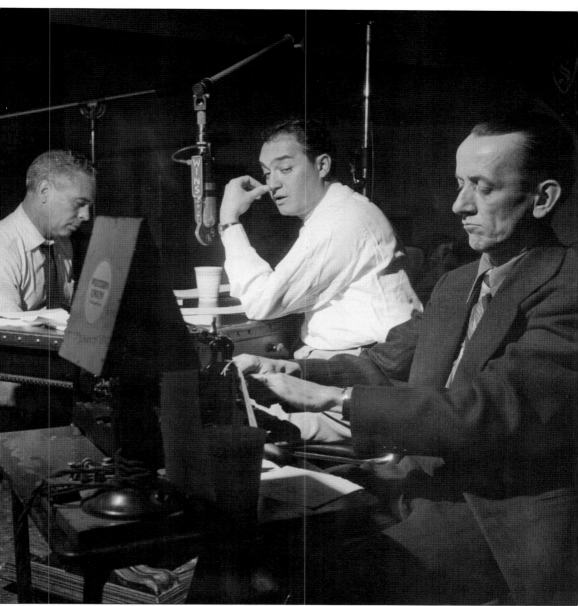

Mel Allen, with the help of a couple of assistants and a Western Union connection, broadcasts an Yankees away baseball game for New York listeners inside a WINS studio. Long-distance, broadcast-quality lines were expensive for radio stations, so clever sportscasters in the pre-television age were often required to re-create out-of-town ball games by using inning-by-inning play information taken off the newswire. With some expert sound effect manipulation and imaginative commentary, most listeners never knew their favorite announcers were often nowhere near the actual game itself.

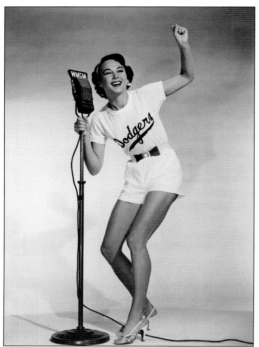

Even though WMGM's commitment to Top 40 rock 'n' roll was growing, the station continued to maintain an impressive (if PR savvy) commitment to sports broadcasting. Former Wimbledon sensation Gussie Moran added a bit of glamour to the station's pre- and post-Brooklyn Dodger game coverage, which she cohosted with Marty Glickman.

WMGM shows off its new Yankees dream team—featuring three of New York's most legendary sportscasters. Pictured here in spring 1958 are, from left to right, (seated) Red Barber, Mel Allen, and Phil Rizzuto with their new bosses Raymond Katz (WMGM program manager, left) and Art Tolchin (WMGM president and director, right) standing proudly behind them. Rizzuto had just started his sportscasting career the previous year at WINS. WMGM would hold the rights to Yankees games until 1961, when WCBS picked them up. (Courtesy Library of American Broadcasting.)

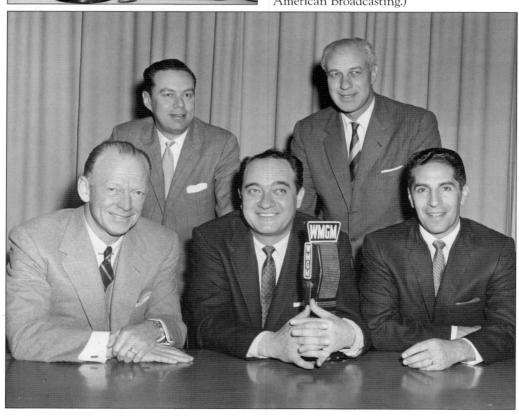

Four

SAVED BY ROCK AND ROLL

A WINS engineer demonstrates a device, looking not unlike a souped-up jukebox with some extra buttons at the top, which may have been used as a means for the station's engineers and deejays to play 45s without having to bother cuing them up on regular turntables. But this photograph can also can serve as a portent of radio's future—not only in terms of stations' increasing automation, but of radio's new short-attention-span, hit-playing, star-making machinery.

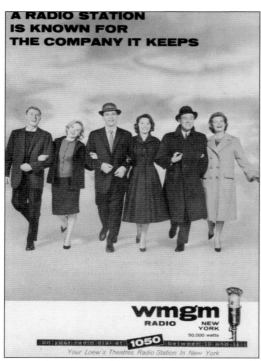

A RADIO STATION
IS KNOWN FOR
THE COMPANY IT KEEPS

wmgm
RADIO NEW YORK
50,000 watts
on your radio dial at **1050** between 10 and 11
Your Loew's Theatres Radio Station in New York

WMGM programmed to all age groups by "dayparting." This advertisement shows "the company it keeps" and the audience it was hoping to find.

Pictured are Alan Freed (left) and Dean Barlow, formerly of the Crickets (not Buddy Holly's Crickets; they came later), at WINS's studios in 1955. Though Freed is remembered for his coining of the term "rock 'n' roll" and his championing of musical pioneers such as Chuck Berry and Little Richard, he built his reputation on playing great, greasy, obscure rhythm-and-blues records that are but a distant memory today.

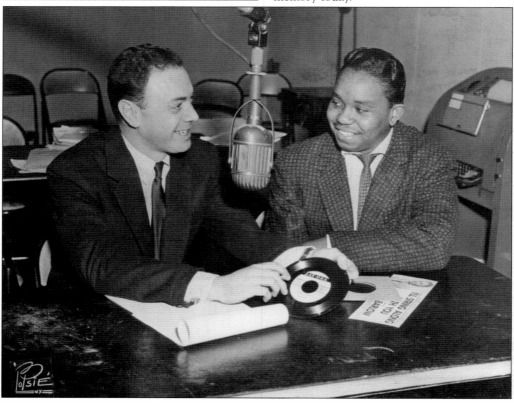

In 1955, *Time* magazine asked, "Is this the most important man in radio?" Though not a "shouter," Bill Randle played an important role in the making of the 1950s biggest pop icons and records. Midwestern deejay Bill Randle was recruited by WCBS from WERE in Cleveland, Ohio, but Randle never completely left the city by the lake, flying constantly between both towns in the late 1950s. Randle had an uncanny knack of finding and breaking major talent.

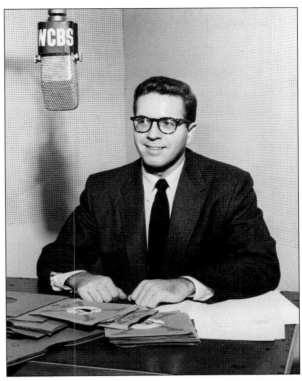

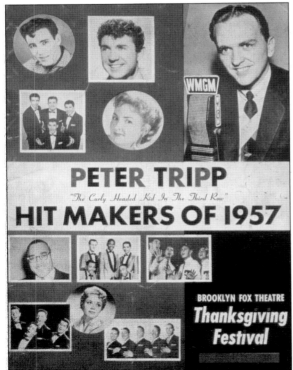

PETER TRIPP
"The Curly Headed Kid In The Third Row"

HIT MAKERS OF 1957

BROOKLYN FOX THEATRE
Thanksgiving Festival

WMGM had evolved into a big-time rock-and-roll competitor to WINS, and Peter Tripp's popularity rivaled Freed's. Known as the "curly-headed kid in the third row," Tripp became best known for a 1959 March of Dimes fundraising stunt in which he stayed awake for five days in a glass-encased booth in Times Square; by the end of the stunt, the initially confident Tripp was hallucinating heavily.

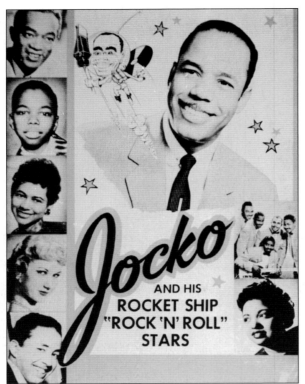

WADO/WOV personality Jocko Henderson presented his own stage shows to counteract Freed and Tripp's stage shows.

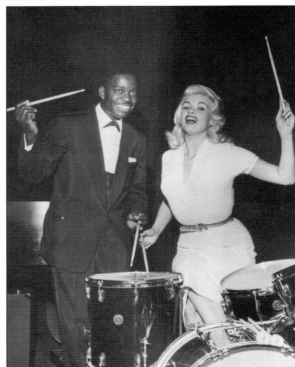

WWRL's "Dr. Jive," also known as Tommy Smalls, is seen here banging the drums with Jayne Mansfield in 1956.

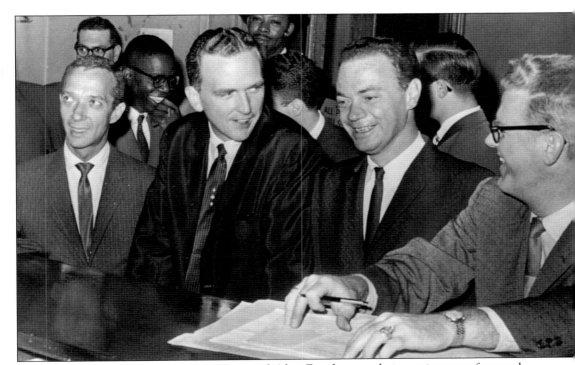

From left to right, Mel Leeds, Peter Tripp, and Alan Freed are at their arraignment for payola charges on April 19, 1960. It seems they are smiling because they considered the whole thing a joke; however, it was not. (Courtesy Library of American Broadcasting.)

John Van Buren Sullivan was the general manager of WNEW in the 1960s. He was as important to WNEW as Bernice Judis.

William B. Williams is pictured here in the mid-1960s on the air at WNEW-AM, which was located at 565 Fifth Avenue.

Marty Glickman, a Syracuse University track star, first started working at WHN in 1939 and became its sports director by 1943. He started broadcasting New York Knicks games in 1946 and memorably teamed up with analyst Al DeRogatis for classic New York Giants football coverage. Marty was a well-loved and up-for-anything sportscaster who worked the big events as well as the smaller/quirkier ones, like roller derbies, rodeos, and even marble tournaments. (Courtesy Library of American Broadcasting.)

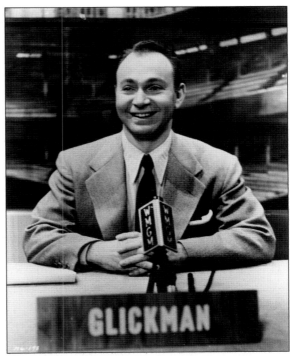

One of Glickman's most motivated protégés, Marv Albert (seen below interviewing an apparently unimpressed Mickey Mantle) would go on to have a long and storied career calling games for the Knicks, the Nets, the Rangers, and for many an NBC and TNT sportscast. Hardworking? Yes!

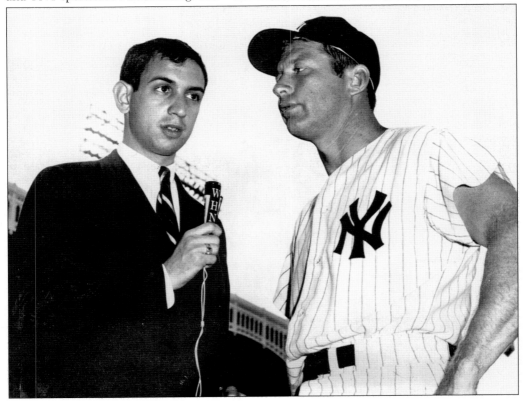

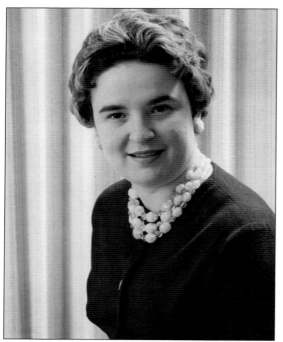

Ruth Meyer was WMCA's program director starting in 1961, a boom year for the station. She was a pioneer female programmer in a major market, bringing the "Good Guys" concept to New York, a format originated in Los Angeles.

WMCA's Gary Stevens prepares for his show. Note the carts behind Gary, containing the station's songs and commercials, a more reliable method than turntable cueing.

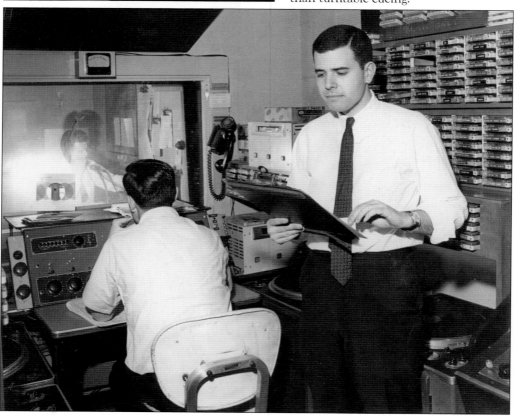

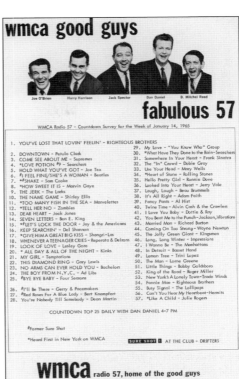

wmca good guys

Joe O'Brien Harry Harrison Jack Spector Dan Daniel B. Mitchel Reed

fabulous 57

WMCA Radio 57 - Countdown Survey for the Week of January 14, 1965

1. YOU'VE LOST THAT LOVIN' FEELIN' - RIGHTEOUS BROTHERS

2. DOWNTOWN - Petula Clark	29. My Love - "You Know Who" Group
3. COME SEE ABOUT ME - Supremes	30. *What Have They Done to the Rain-Searchers
4. *LOVE POTION #9 - Searchers	31. Somewhere In Your Heart - Frank Sinatra
5. HOLD WHAT YOU'VE GOT - Joe Tex	32. The "In" Crowd - Dobie Gray
6. #I FEEL FINE/SHE'S A WOMAN - Beatles	33. Use Your Head - Mary Wells
7. *#SHAKE - Sam Cooke	34. *Heart of Stone - Rolling Stones
8. *HOW SWEET IT IS - Marvin Gaye	35. Hello Pretty Girl - Ronnie Dove
9. THE JERK - The Larks	36. Looked Into Your Heart - Jerry Vale
10. THE NAME GAME - Shirley Ellis	37. Laugh, Laugh - Beau Brummels
11. *TOO MANY FISH IN THE SEA - Marvelettes	38. It's All Right - Adam Faith
12. *TELL HER NO - Zombies	39. Fancy Pants - Al Hirt
13. DEAR HEART - Jack Jones	40. Twine Time - Alvin Cash & the Crawlers
14. SEVEN LETTERS - Ben E. King	41. I Love You Baby - Dottie & Ray
15. *LET'S LOCK THE DOOR - Jay & the Americans	42. You Beat Me to the Punch-Jackson,Vibrations
16. KEEP SEARCHIN' - Del Shannon	43. Married Man - Richard Burton
17. *GIVE HIM A GREAT BIG KISS - Shangri-Las	44. Coming On Too Strong - Wayne Newton
18. WHENEVER A TEENAGER CRIES - Reparata & Delrons	45. The Jolly Green Giant - Kingsmen
19. LOOK OF LOVE - Lesley Gore	46. Long, Long Winter - Impressions
20. * ALL DAY & ALL OF THE NIGHT - Kinks	47. I Wanna Be - The Manhattans
21. MY GIRL - Temptations	48. In Detroit - Basset Hand
22. THIS DIAMOND RING - Gary Lewis	49. Lemon Tree - Trini Lopez
23. NO ARMS CAN EVER HOLD YOU - Bachelors	50. The Man - Lorne Greene
24. THE BOY FROM N.Y.C. - Ad Libs	51. Little Things - Bobby Goldsboro
25. #BYE BYE BABY - Four Seasons	52. King of the Road - Roger Miller
	53. New York's A Lonely Town-Trade Winds
26. #I'll Be There - Gerry & Pacemaker	54. Fannie Mae - Righteous Brothers
27. #Red Roses For A Blue Lady - Bert Koempfert	55. Busy Signal - The Lollipops
28. You're Nobody Till Somebody - Dean Martin	56. Can't You Hear My Heartbeat-Hermits
	57. *Like A Child - Julie Rogers

COUNTDOWN TOP 25 DAILY WITH DAN DANIEL 4-7 PM

#Former Sure Shot

*Heard First in New York on WMCA SURE SHOT █ AT THE CLUB - DRIFTERS

wmca radio 57, home of the good guys

Pictured at right is a WMCA music survey chart from January 1965. Although the station listed 57 songs, it mostly played the top 30 or so over and over. Numbers above 40 could usually be heard once or twice a day and often only between the hours of 1:00 a.m. and 6:00 a.m. Below, Gary Stevens and Joe O'Brien show off their formal Good Guys sweatshirts in the WMCA lobby. "I always thought that WMCA was more New York to me than WABC was," WCBS-FM program director Joe McCoy told journalist Jerry Barmash at the time of Ruth Meyer's passing in 2011. "I thought the only person on ABC that was really New York was 'Cousin' Brucie. When you look at 'MCA and the things that they did with those little corny songs . . . it just reminded me that it was New York."

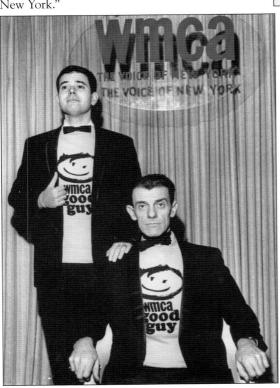

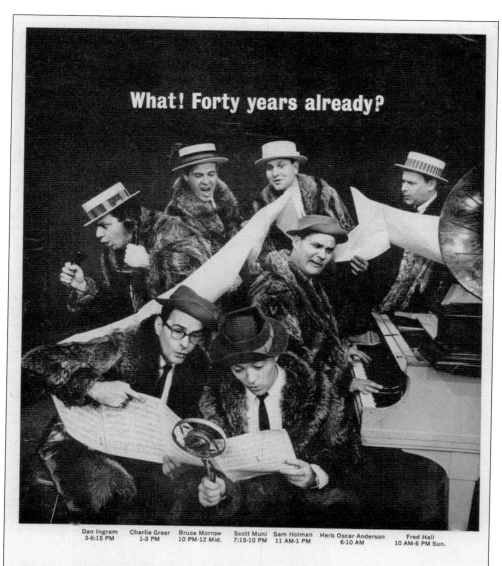

| Dan Ingram
3-6:15 PM | Charlie Greer
1-3 PM | Bruce Morrow
10 PM-12 Mid. | Scott Muni
7:15-10 PM | Sam Holman
11 AM-1 PM | Herb Oscar Anderson
6-10 AM | Fred Hall
10 AM-6 PM Sun. |

Time flies. So does WABC. And so do the delighted listeners to the Swingin' Seven from 77. Fly with us to our Fortieth Birthday Party. Special features. Special events. Extra Special prizes and surprises. All day. All month. And, of course, First Person News, Your Kind of Music. All the time on THE NEW SOUND OF NEW YORK.

WABC RADIO CHANNEL 77
on your sound dial

WABC's "Swingin' Seven" humorously celebrate the 40th anniversary of the station. (WJZ, the flagship of NBC's Blue Network, had been renamed as WABC in 1953, sensibly taking on the initials of its affiliated network—the American Broadcasting Company; meanwhile, the old, confusingly named WABC had been renamed as WCBS.) Whatever the backstory, at that moment, the station had its eyes firmly on its present and its future as one of the nation's most successful and imitated Top 40 radio stations.

In 1956, a WINS deejay named Bruce Morrow met a "sweet white-haired lady" who asked him: "Do you believe we're all related? Well, cousin, lend me 50 cents to get home!" And . . . well, the rest is history. He may not have had the suavest delivery or calmest demeanor, but it is hard to imagine a more warmly remembered and well-loved radio character than Cousin Brucie—seen here chatting with The Beatles on behalf of WA-Beatle-C.

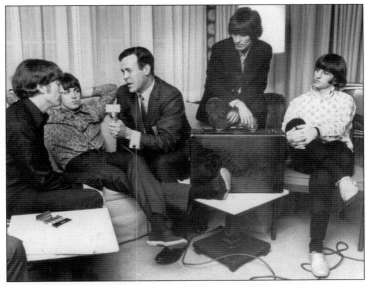

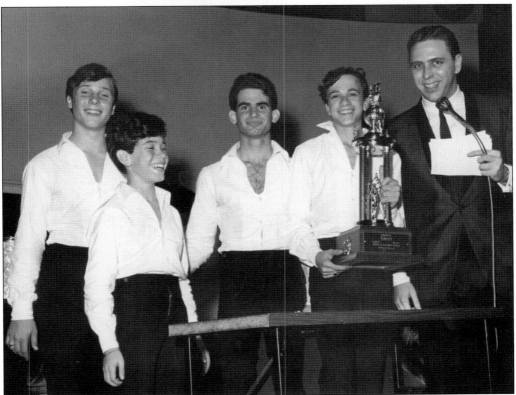

WABC's Bob Lewis hosted a Macy's-sponsored battle of the bands in 1965 (the gratified winners seen here were local band the Rocking Angels). The well-liked "Bob-a-Loo" held down the unforgiving night shift at 77 for several years until begging off it; he ended up later as a refreshingly low-key deejay on several of the city's FM underground stations and went on to a successful voice-over career by the mid-1970s.

"Murray the K" Kaufman (left) poses above with, from left to right, WINS record librarian Julie Ross, "king of the surf movies" Frankie Avalon, and fellow WINS deejay Johnny Holliday in 1964. The fast-talking and relentlessly upbeat Kaufman started out as a Borscht Belt hustler turned talk-show producer at WMCA, rising to fame after taking over the WINS evening shift from a disgraced Alan Freed. He is best remembered today as "the Fifth Beatle," even though competitors WABC and WMCA had much stronger claims on being the city's preeminent Beatles stations. Below, WNEW's Pete "Mad Daddy" Myers digs James Bond's Aston Martin at the 1965 New York World's Fair. Myers came up with his brilliantly weird on-air persona in Ohio in the late 1950s, where he introduced rhythm-and-blues and rock records with a surreal mix of rhyme, reverb, and sound effects. He moved to New York and went on to work at both WNEW and WINS, but as the years moved on, Myers became deeply worried he was going to lose his WNEW air shift and committed suicide on October 4, 1968. He was a radio genius gone far too soon.

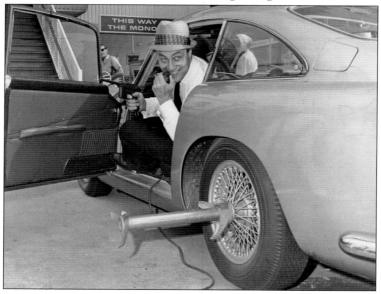

Polito Vega got his start in 1959 on WEVD-AM shortly after arriving to New York from Puerto Rico and realizing he was never going to make the cut as a singer. More than 50 years later, he is still a stalwart of the city's Hispanic radio scene, broadcasting classic salsa on WSKQ-FM. (Courtesy Polito Vega.)

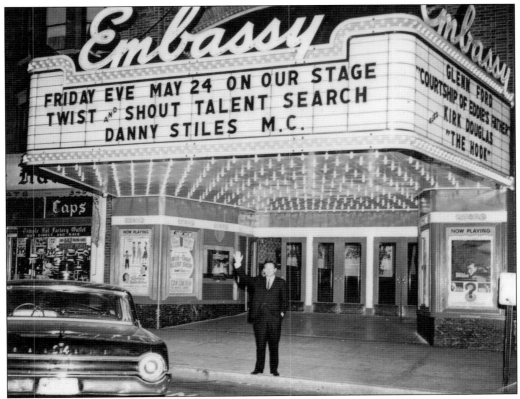

A waving Danny Stiles stands in front of the Embassy Theater in Orange, New Jersey. He was by now a well-established and well-loved jock at the Union, New Jersey–based rhythm-and-blues station WNJR, known by one and all as the "Cat Man." (Courtesy Gary Stevens.)

Bob Elliott and Ray Goulding, commonly known as "Bob and Ray," moved to New York from Boston in the early 1950s and proceeded to work at a dizzying array of stations and networks: CBS, NBC ("Monitor"), WINS, WHN, WOR, and even at underground WNEW-FM. Elliott and Goulding were brilliantly funny with endlessly flexible dry wits, and their "Mary Backstage, Noble Wife" is far better remembered than the radio soap it spoofed, *Mary Noble, Backstage Wife*. (Courtesy Library of American Broadcasting.)

WOR's Jean Shepherd, radio monologist nonpareil, is seen here being interviewed at WITR, the college station at the Rochester Institute of Technology in the fall of 1968. (WOR's 50,000-watt signal provided Shepherd with an unusually widespread audience.) "Shep" may be best known today for writing and narrating the well-loved holiday film A *Christmas Story*, but WOR was where he really shined, weaving elaborate, semiautobiographical/semi-fictional tales long into the night from the station's Times Square studios (and occasionally from the transmitter in Carteret). An ornery and hard-to-get-to-know character, Shepherd was the real deal, a genuine radio genius. His shows, filled with ostensibly mundane details that became epic in their telling, are well worth seeking out not only for radio fans, but for anyone who appreciates a beautifully told tale. (Courtesy Mary Anne Powell.)

This is the 1010 WINS newsroom on Sunday, April 18, 1965—a day before the station's fateful format change. In late 1964, news director Stan Brooks (third from left, reviewing copy) was already secretly assembling an air staff for the nation's first all-news radio station. Nearly 50 years later, both Brooks and WINS are still going strong and giving the listeners "all news, all the time."

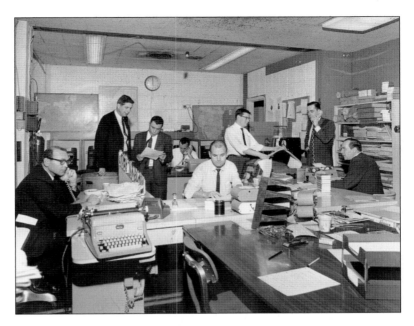

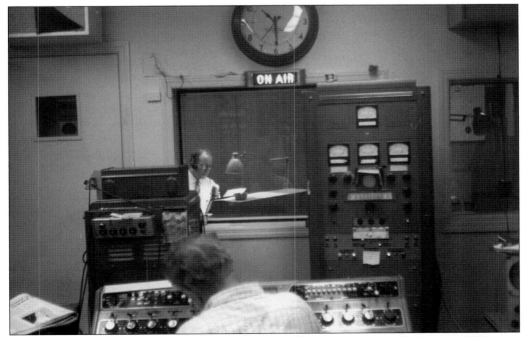

This mid-1960s image shows WPAT's studio, located off the Garden State Parkway in Clifton. In the early 1950s, Dickens Wright's revolutionary "Gaslight Revue" format became a near overnight success with its carefully assembled collection of easy-listening instrumental programmed in 28-minute themed blocks. The soothing and soon widely imitated WPAT format appealed to postwar suburban mothers and fathers. (Courtesy Jim Hawkins.)

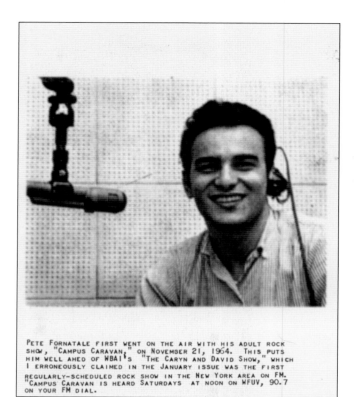

A 19-year-old man named Pete Fornatale is pictured here at the beginning of a distinguished career. His *Campus Caravan* show is widely believed to be the first regularly scheduled rock show on FM radio, debuting on Fordham University's WFUV on November 21, 1964. (Courtesy Martin Brooks.)

PETE FORNATALE FIRST WENT ON THE AIR WITH HIS ADULT ROCK SHOW, "CAMPUS CARAVAN," ON NOVEMBER 21, 1964. THIS PUTS HIM WELL AHED OF WBAI's "THE CARYN AND DAVID SHOW," WHICH I ERRONEOUSLY CLAIMED IN THE JANUARY ISSUE WAS THE FIRST REGULARLY-SCHEDULED ROCK SHOW IN THE NEW YORK AREA ON FM. "CAMPUS CARAVAN IS HEARD SATURDAYS AT NOON ON WFUV, 90.7 ON YOUR FM DIAL.

Before the "underground rock" FM radio revolution fully took hold in 1967, station managers seemed ready to try almost anything to get attention. From WNEW-FM's short-lived experiment with an all-female air personality lineup, only Alison Steele (left) would go on to greater glory. WNEW aggressively promoted the format, but it was just too early in the history of FM for such stunts to make much of an impact. (Courtesy Martin Brooks.)

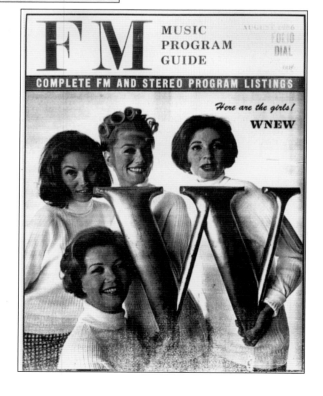

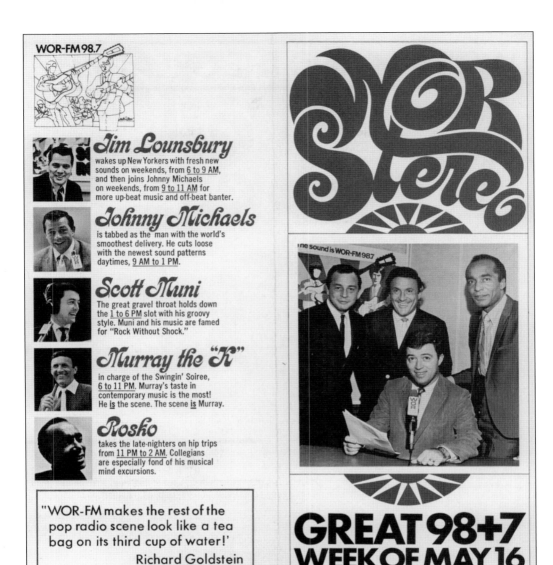

WOR-FM 98.7

Jim Lounsbury
wakes up New Yorkers with fresh new sounds on weekends, from 6 to 9 AM, and then joins Johnny Michaels on weekends, from 9 to 11 AM for more up-beat music and off-beat banter.

Johnny Michaels
is tabbed as the man with the world's smoothest delivery. He cuts loose with the newest sound patterns daytimes, 9 AM to 1 PM.

Scott Muni
The great gravel throat holds down the 1 to 6 PM slot with his groovy style. Muni and his music are famed for "Rock Without Shock."

Murray the "K"
in charge of the Swingin' Soiree, 6 to 11 PM. Murray's taste in contemporary music is the most! He is the scene. The scene is Murray.

Rosko
takes the late-nighters on hip trips from 11 PM to 2 AM. Collegians are especially fond of his musical mind excursions.

"WOR-FM makes the rest of the pop radio scene look like a tea bag on its third cup of water!'
Richard Goldstein
the village VOICE

the sound is WOR-FM 987

GREAT 98+7
WEEK OF MAY 16
WOR/FM 98.7 NEW YORK • ISSUE No. 1

This is the original, legendary 1966–1967 lineup at WOR-FM, featuring refugees from the AM band, including WINS's Murray the K and WABC's Scott Muni, who were about to take it down a notch, delivery-wise. For a brief period, WOR-FM would be the epitome of underground radio with "groovy" deejays playing all the "psychedelic" rock 'n' roll they wanted to play; the rules of tightly formatted radio, at least for a little while, seemed to go out the window.

Tolstoy's WAR AND PEACE

READ IN ITS ENTIRETY, BEGINNING WEDNESDAY, DECEMBER 2, 7:15 P.M., 08

WBAI - 99.5 FM

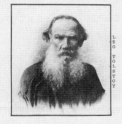

LEO TOLSTOY

READERS INCLUDE

Richard Avedon	Ben Gazzarra	Mitch Miller
Theodore Bikel	Rabbi Bruce Goldman	Paul O'Dwyer
Mel Brooks	August Heckscher	Joseph Papp
Bill Buckley	Joseph Heller	Tony Randall
Carter Burden	Buck Henry	Dore Schary
Morris Carnovsky	Dustin Hoffman	Pete Seeger
Bennett Cerf	James Earl Jones	Rip Torn
Judith Crist	Stacy Keach	Ernest van den Haag
Howard da Silva	Evelyn Lear	George Wald
Ruby Dee	Frank Langella	Fay Wray
Ann Dunnigan	Conrad Lynn	Zacherle
Jonathan Frid	Norman Mailer	AND MANY MORE

** AND ALEXANDRA TOLSTOY, LEO TOLSTOY'S DAUGHTER**

PRODUCED BY MILTON HOFFMAN AND KATHY DORKIN FOR WBAI, LISTENER-SPONSORED,
NON-COMMERCIAL RADIO IN NEW YORK CITY
-A CENTENNIAL CELEBRATION-

WFMU was founded in 1958 as the radio station for a small South Orange–based private university named Upsala College. But by the mid-1960s, the station was becoming an early and important bastion of what was to become free-form radio. Lou "The Duck" D'Antonio, pictured above, a fan of Jean Shepherd and Bob and Ray, joined the station in 1962. He started out hosting an eclectic jazz program and stayed on at the station through 1990. Along with Vin Scelsa, D'Antonio helped define the legendary and still uncompromising WFMU legacy, which has long outlasted Upsala College itself. Meanwhile, what other radio station—other than Pacifica's legendary (and ever-embattled) WBAI—would broadcast a reading of Leo Tolstoy's *War and Peace*, as advertised in the image at left? WBAI attracted on-air readers such as Mel Brooks, Tony Randall, Norman Mailer, Dustin Hoffman, Fay Wray, and John Zacherle. (Above, courtesy WFMU; left, courtesy Library of American Broadcasting.)

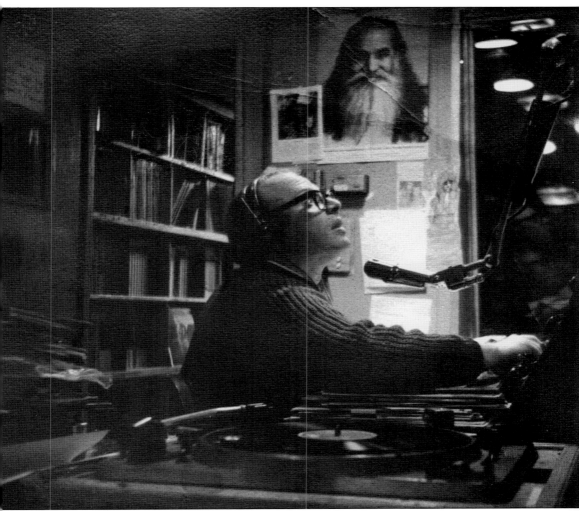

Bob Fass started doing all-night shows at WBAI in 1959 and still can be heard on the station's late-shift today. One of the first and most influential free-form deejays, Fass's all-nighters (frequented by the likes of Bob Dylan, Abbie Hoffman, and John Lennon) were genuine happenings, a gathering place for the weird and wired of New York City. The 2012 documentary *Radio Unnameable* is an essential introduction to Fass's important and unique legacy. (Courtesy Bob Fass.)

At left, William Reumann cuts a cake on July 23, 1963, the 25th anniversary of his station WWRL going full time. (In 1938, the FCC had ruled that the station would no longer have to share its then frequency of 1,500 kilocycles with Brooklyn's WMBQ.) Reumann was a lifelong radio enthusiast and entrepreneur, getting his first ham radio license in 1912. His beloved WWRL would become an important part of New York's radio history—especially in terms of its minority-oriented programming. Pictured below is a WWRL "Soul 16" music survey chart. It is interesting to note Procol Harum's high placement on the list, as they were a band one might not have expected to see anywhere on a rhythm-and-blues-oriented stations' chart. (Left, courtesy Library of American Broadcasting.)

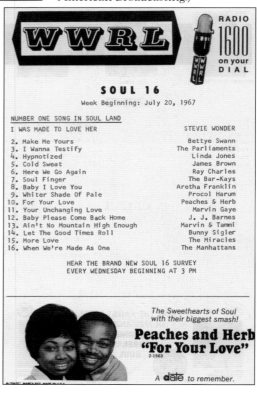

WWRL RADIO **1600** on your DIAL

SOUL 16
Week Beginning: July 20, 1967

NUMBER ONE SONG IN SOUL LAND

I WAS MADE TO LOVE HER	STEVIE WONDER
2. Make Me Yours	Bettye Swann
3. I Wanna Testify	The Parliaments
4. Hypnotized	Linda Jones
5. Cold Sweat	James Brown
6. Here We Go Again	Ray Charles
7. Soul Finger	The Bar-Kays
8. Baby I Love You	Aretha Franklin
9. Whiter Shade Of Pale	Procol Harum
10. For Your Love	Peaches & Herb
11. Your Unchanging Love	Marvin Gaye
12. Baby Please Come Back Home	J. J. Barnes
13. Ain't No Mountain High Enough	Marvin & Tammi
14. Let The Good Times Roll	Bunny Sigler
15. More Love	The Miracles
16. When We're Made As One	The Manhattans

HEAR THE BRAND NEW SOUL 16 SURVEY
EVERY WEDNESDAY BEGINNING AT 3 PM

The Sweethearts of Soul
with their biggest smash!

Peaches and Herb
"For Your Love"
2-1563

A **date** to remember.

In the late 1960s, WMCA, a New York radio station with a white air staff, largely white audience, and fierce competitor in WABC, wisely decided to expand its market. Frankie Crocker (right), a veteran of WWRL, would be the man for the job. The move allowed the station and Crocker to cross listenership lines and reduce formatting restrictions. After proving his credibility at WMCA, Crocker was hired as the programming director and a deejay at WLIB-AM in 1971 and later became the main voice of WLIB-FM—a station that soon changed its call letters to WBLS. Crocker hosted the afternoon drive-time slot from 4:00 p.m. to 8:00 p.m., a time slot he kept throughout his tenure with WBLS. Also at WLIB-AM and WBLS-FM was the legendary Hal Jackson, a veteran of the airwaves since 1939 (and survivor of the payola scandals). Jackson, one of the nicest and most talented men in New York City radio, is seen below with Bill Cosby and the Reverend Jesse Jackson. From the 1940s to well into the 21st century, Jackson saw it all and did it all with an elegance that was rarely matched. (Right, courtesy Library of American Broadcasting; below, courtesy Debi Jackson.)

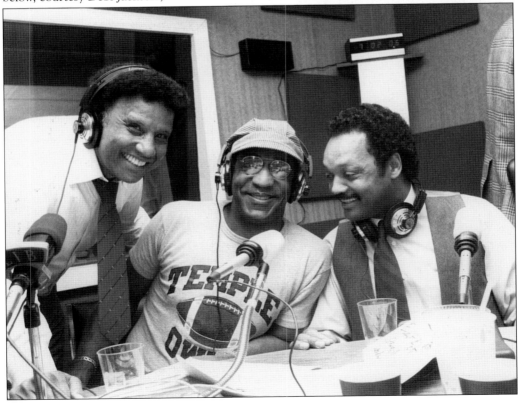

This is a scene to warm a New Yorker's heart. The city's finest rock and soul band, The Rascals, is seen here "encouraging" Dan Ingram, perhaps the most brilliant and quick-witted of WABC's deejays, with music cartridges of their own songs in 1967. Most radio stations did not play records by this time; instead, they played prerecorded "carts" of the individual songs. Carted or not, when one heard Dan Ingram introing a Rascals record on WABC's air, all was well with the world.

WABC's program director Rick Sklar (left), a veteran of WINS in the Alan Freed years, was a promotional genius and a major reason why Musicradio 77 was such a tremendous success. Here, Sklar figured out a tie-in for the occasion of the original *Mona Lisa*'s visit to the city: a listener Mona Lisa drawing contest. The station was swamped with so many entries that the Polo Grounds were used as the location for the judging.

84

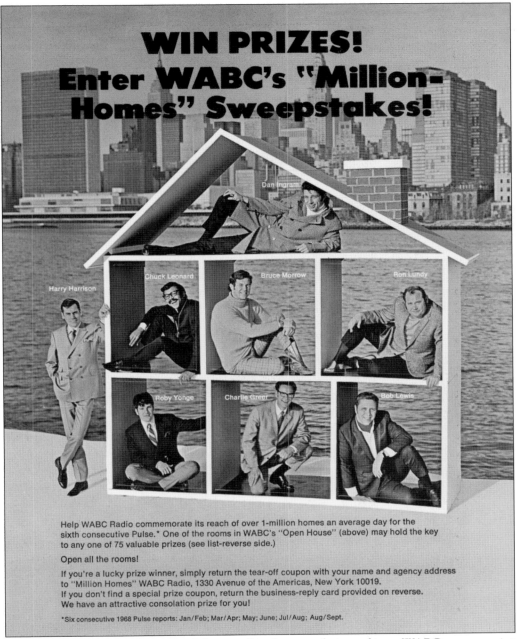

WIN PRIZES!
Enter WABC's "Million-Homes" Sweepstakes!

Dan Ingram

Harry Harrison

Chuck Leonard

Bruce Morrow

Ron Lundy

Roby Yonge

Charlie Greer

Bob Lewis

Help WABC Radio commemorate its reach of over 1-million homes an average day for the sixth consecutive Pulse.* One of the rooms in WABC's "Open House" (above) may hold the key to any one of 75 valuable prizes (see list-reverse side.)

Open all the rooms!

If you're a lucky prize winner, simply return the tear-off coupon with your name and agency address to "Million Homes" WABC Radio, 1330 Avenue of the Americas, New York 10019.
If you don't find a special prize coupon, return the business-reply card provided on reverse.
We have an attractive consolation prize for you!

*Six consecutive 1968 Pulse reports: Jan/Feb; Mar/Apr; May; June; Jul/Aug; Aug/Sept.

By 1969, ratings services determined that a million homes a day tuned in to WABC at some point during an average day. To celebrate this notable achievement, Sklar asked the current air staff to pose inside its "Open House," with the New York skyline looming glamorously in the back. Looking at this lineup of the city's top jocks is not unlike gazing upon a photograph of the 1927 Yankees; simply put, these guys were the champions of the New York radio market. (With the exception, that is, of Roby Yonge, whose stay at WABC would be cut short due to his infamous Paul McCartney is dead broadcast on the night of October 21.)

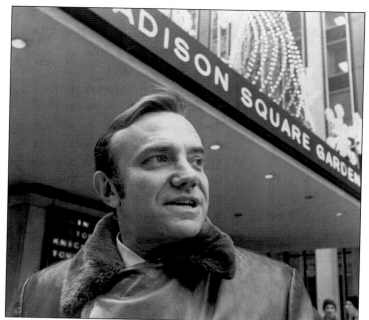

The "Amazin' " Bill Mazer launched the first well-publicized and popular sports call-in talk show on WNBC-AM. It was an innovation that would stick; sports radio is flourishing now more than ever, and it would be unimaginable without opinionated and feisty hosts interacting with opinionated and feisty callers.

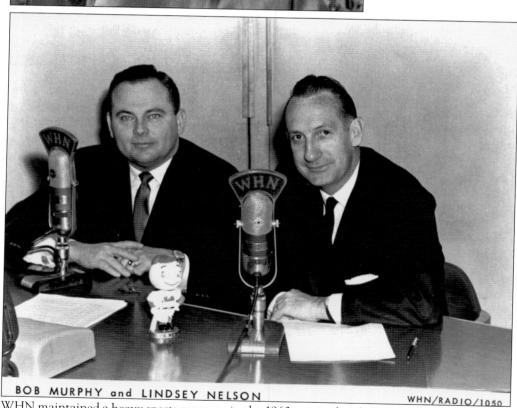

BOB MURPHY and LINDSEY NELSON WHN/RADIO/1050

WHN maintained a heavy sports presence in the 1960s, airing baseball and hockey games. Here is two-thirds of the Mets' classic broadcasting lineup near the beginning of their tenure: Bob Murphy (left) and Lindsay Nelson.

N FAIRCHILD BOB GRANT LEON LEWIS

.L SCOTT JOHN STERLING BARRY GRAY

WMCA is seen here in the early 1970s when full-time talk radio was first beginning to blossom. In this pre-Limbaugh era, there was a greater diversity of voices and political worldviews than radio has now.

It is little remembered today, but WCBS-FM did not start out as New York's favorite oldies station. In 1969, the station decided to take a WOR-FM–like approach but aimed for a slightly older, yet still alternative, audience. Bill Brown (left) remained on the station through its 1972 format changeover to oldies and stayed on until the bitter end; that is, when WCBS-FM abruptly turned to the "Jack" format in 2005. From left to right are Brown, Dick "Buffalo" Birch, Ed Williams, Bobby Wayne, and Les Turpin. (Courtesy Martin Brooks.)

"The opinions expressed on this program do not necessarily represent the views of the management or any of the sponsors of WABC-FM and/or the American Broadcasting Company."

Michael Cuscuna
Call 541-8150
6:15-10:15AM Mon.thru Fri.
95½ WABC FM

MUSIC-NEWS-WEATHER-TELEPHONE TALK-INTERVIEWS

Like WCBS-FM, WABC's management was not quite sure what to do with its FM counterpart in the 1960s. Initially broadcasting Broadway show tunes (when it was not simply simulcasting the WABC AM signal), the station became something of a workshop for the AM staff; Dan Ingram had a low-key jazz show, for example. But by 1970, the station was attempting to be an free-form underground station, and Michael Cuscuna served as its radical morning man, mixing music with talk and politics.

Brooklyn native Alison Steele was a member of the ill-fated 1966 "all-girl" WNEW-FM format, but unlike the other members of the female on-air staff, she stayed on as the station's night deejay as the station entered its classic underground era. Initially not too knowledgeable about the burgeoning genre of progressive rock, Steele created her sexy and soulful "Nightbird" persona, which was particularly popular with male audiences.

Now this is classic rock. Ian Anderson of Jethro Tull poses with Dennis Elsas and Scott Muni at WNEW-FM, by now the nation's leading alternative rock station. Note the old school WNEW-AM posters (Lonny Starr and Klavan & Finch) on the back wall; WNEW-AM was still going strong, right across the hallway. The AM deejays frequently mentioned, with distaste, the "hippies" on the other side of the building. (Courtesy Dennis Elsas.)

The great Bwana Johnny is pictured at WWDJ in Hackensack, a fondly remembered Top 40 station that almost gave WABC a run for its money between 1972 and 1974. (It would have, if its signal had been stronger. Note the rack of duplicate 45s in the background; apparently not all stations had switched to carts by then. (Courtesy John Porcaro.)

Johnny Donovan is seen here back in his WOR-FM days. But he would soon start working at—and be forever associated with forthwith—WABC, where he can still be heard today on intros, outros, promos, and bumpers.

TO SUM UP THE MEETING AND TO HAVE A WRITTEN RECORD OF WHAT WENT DOWN TODAY, I'LL COVER EVERYTHING ONE STEP AT A TIME:

A) WE ARE USING TEASE LINERS AT :03 AND :33 (ex. "98.7 GOIN' THRU GOOD CHANGES... BE LISTENING.....MONDAY (TOM) (THIS) MORNING !) NO TALK FOLLOWING THE LINERS..... AND SELL 'EM HARD ! DO NOT USE "OR-FM" IN THOSE LINERS. THE LINERS RUN UP TO PUBLIC SERVICE MONDAY MORNING.

B) WXLO STARTS AT 5AM MONDAY. 98.7 GIVES BIRTH TO A MONSTER WHO EATS UP RADIO STATIONS (NAMELY WABC AND WWDJ). JIMMY KICKS IT OFF BY SEGUEING MUSIC OUT OF THE 4:40 NEWS WITH NO TALK, NO LOGOS, NO NOTHIN'.....AND THEN AT 5, THE "ROCK ON" ID IS FIRED OFF AND WE'RE ON OUR WAY (UP).

C) WE WILL INITIALLY BE USING "XLO" IN ALL BACKSELLS.....IN EVERYTHING.....BUT NO CRIME IF YOU OCCASIONALLY USE THE "W".

D) THE LOGOS ARE ALL NEW AND ARE NUMBERED AS FOLLOWS:

 L1) COOKER ("WXLO" UP)

 L2) BALLAD ("WXLO" DOWN)

 L3) 2 CUTS ("STEREO XLO")
 ("98.7 XLO")

IT GOES AT :15 AND :45 AND BOTH CUTS WILL BE ON ONE CART (L3) SO IT WILL ALWAYS BE ALTERNATED. I KNOW WHAT 2 DIFFERENT CUTS ON ONE CART CAN MEAN.....BUT IT MUST BE THAT WAY.....GET USED TO 'EM. THEY BOTH END WITH XLO REMEMBER ! LOGO PLACEMENT REMAINS THE SAME AND STILL NO TALK AFTER L3.

THE ID "WXLO NEW YORK.....ROCK ON" IS FOLLOWED BY A COOKER AND NO TALK.....STRAIGHT SEGUE ! YOUR SIGN ON WILL COME AT :03.....USE YOUR NAME THERE, NOT AT :06 IN YOUR FIRST HOUR.

E) XLO PRIZE PAYOFF

PRE PROMOS START MONDAY.....THERE ARE 2, A 10 SECOND JOB AT :36 AND A LONGER (ABOUT 30) PROMO AT :06. NO TALK FOLLOWING EITHER PROMO, SO YOUR NAME GOES IN THE BACKSELL INTO :06 AND :36.

LINER ORDER (EFFECTIVE 5AM MONDAY):

 :03 XLO SELL :33 XLO SELL

 :20 PRIZE PAYOFF :50 PRIZE PAYOFF

F) GET USED TO 4 LINERS AN HOUR. THE OBJECTIVE IS TO MAKE XLO A HOUSEHOLD WORD AND WE'RE GONNA SELL THE HELL OUT OF IT. I WANT 5 XLO SELL LINERS FROM EVERYONE BY 10 AM THURSDAY.

I'LL COVER MECHANICS ON PRIZE PAYOFF NEXT WEEK.....IT'S SIMPLE AND GIVES US TREMENDOUS IMPACT WITH THE NEW CALL LETTERS.....AND A LOT OF MOMENTUM..... IT'S A WINNER !

NOW.....IT'S ALL ON PAPER.....ON MONDAY IT'S REAL. IF YOU THINK YOU'VE BEEN WORKING UP TILL NOW, ON MONDAY WE NEED TWICE AS MUCH EFFORT.....TWICE AS MUCH ENERGY.....TWICE AS MUCH EVERYTHING.....OUR JOB IS TO MAKE XLO A HOUSEHOLD NAME... WE'VE GOTTA SELL IT.....PUT IT ACROSS.....AND WITH A SUPREME EFFORT FROM EVERYONE WE'LL DO IT. USE THIS WEEKEND TO THINK ABOUT THE COMMITMENT YOU HAVE TO THIS STATION, THINK ABOUT THE CONTRIBUTIONS YOU CAN MAKE.....DEDICATE YOURSELF COM- PLETELY TO THE TASK AHEAD AND ON MONDAY GET IT ON WITH EVERYTHING YOU'VE GOT !

Pictured is a fascinating behind-the-scenes look at the birth of a new radio station (WXLO/"99X") and the death of an old one (WOR-FM). Written on Friday, October 20, 1972, the station's program director Mel Phillips expounds on the "teases" to be read over the weekend, the post-launch announcer directions, and the jingle info for the new format, which launched at 5:00 a.m. on Monday October 23. 99X was an aggressive, upbeat, contest-filled Top 40 competitor to WABC, featuring a cast of deejays that included Walt "Baby" Love, Jay Thomas, Sue O'Neil, and Al Bandiero, who helped the station maintain strong ratings throughout the 1970s. By the end of the decade, however, the Top 40 audience was fragmenting, and the disco onslaught of WKTU—alongside the less-hyped-up AOR (album-oriented rock) stylings of WPLJ—would spell the end of WXLO, which eventually would become the urban contemporary WRKS (Kiss FM).

John Donald Imus Jr., known for his show *Imus in the Morning*, was an itinerant railroad brakeman, songwriter, and ne'er-do-well before he became a deejay with a reputation for doing funny things, like ordering 1,200 cheeseburgers from a Sacramento McDonald's. He was hired away from Cleveland station WGAR by a nothing-to-lose WNBC-AM in December 1971. Imus quickly became the toast of New York as the town's first real shock jock with great press (*Life* magazine called Imus the "country's most outrageous deejay"), rising ratings, and a reputation for saying whatever was on his mind. And now, 40 years later, after some comings and goings, bouts of alcoholism, controversies, rivalries, and even more controversy (specifically, an unwise Rutgers women's basketball team comment in 2007 that got him fired from WFAN), Imus abides with his curmudgeonly WABC political chat show, neither too right nor too left but often still surprisingly smart and funny. *The American Spectator* calls Imus "the last great example of the metropolitan American art form of morning radio," and they may be right.

Above, "Wolfman Jack" was a Brooklyn kid named Robert Smith who grew up living and loving the radio; he was a huge fan of Jocko Henderson, Dr. Jive, and Danny "Catman" Stiles. Smith set out on his own career as a gravelly voiced deejay, ending up at a 250,000-watt Mexican station XERF and eventually landing a small but legendary deejay role in George Lucas's brilliant *American Graffiti*. WNBC, buoyed by its success with Imus and gunning for WABC, hired Wolfman in 1973 specifically to "bury" Cousin Brucie. Wolfman is seen above being welcomed by the Ad Libs of "Boy From New York City" fame.) Cousin Brucie, seen below, was, and still is, simply too much of a New York institution to be buried, and by 1974, WNBC realized they could not beat him. So they hired him.

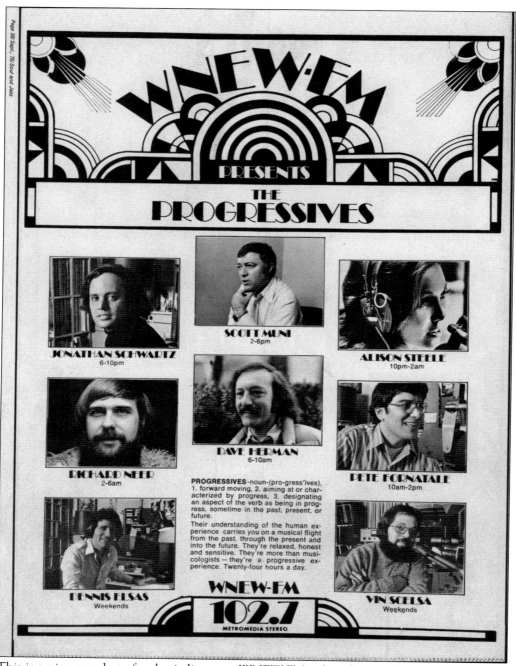

WNEW-FM PRESENTS THE PROGRESSIVES

JONATHAN SCHWARTZ
6-10pm

SCOTT MUNI
2-6pm

ALISON STEELE
10pm-2am

RICHARD NEER
2-6am

DAVE HERMAN
6-10am

PETE FORNATALE
10am-2pm

PROGRESSIVES -noun-(pro-gress'ives), 1. forward moving, 2. aiming at or characterized by progress, 3. designating an aspect of the verb as being in progress, sometime in the past, present, or future.
Their understanding of the human experience carries you on a musical flight from the past, through the present and into the future. They're relaxed, honest and sensitive. They're more than musicologists — they're a progressive experience. Twenty-four hours a day.

DENNIS ELSAS
Weekends

VIN SCELSA
Weekends

WNEW-FM
102.7
METROMEDIA STEREO

This is a nice snapshot of a classic lineup at WNEW-FM, taken during the height of its heavy karma in the mid-1970s. (Courtesy NY Radio Archive.)

William Roscoe Mercer, simply known as "Rosko" by his listeners, was living in France after his adventures in the New York FM's underground when he received a call to help launch a new rock station: quadraphonic WQIV. Rosko tried his best, but quadraphonic technology was not exactly ready for prime time.

Roger McGuinn of the Byrds (left) is pictured with the great Pete Fornatale at WNEW-FM. The building at 565 Fifth Avenue truly was "Where Rock Lives."

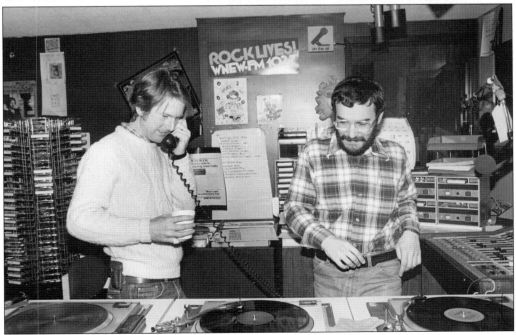

Detroit native Pat St. John came to New York to work at WPLJ, which was a much more tightly formatted AOR (album oriented rock) station than WABC-FM. Playlists were tightening and times were changing, but Pat St. John would not cut his hair, no matter what. (Courtesy Pat St. John.)

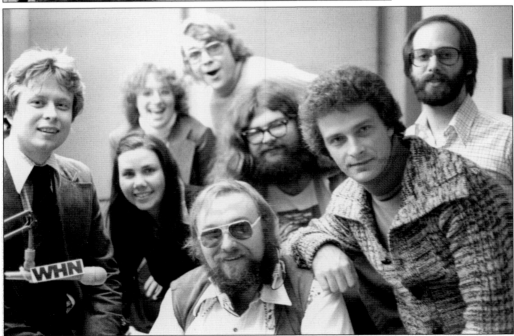

Rising country star Charlie Daniels (a couple of years before "The Devil Went Down to Georgia") visits WHN in 1977. The station never explicitly called itself "country" and, in doing so, became the second most popular station in New York City. At far left is influential country programmer Ed Salamon (who would go on to write Arcadia Publishing's *Pittsburgh's Golden Age of Radio*), music director Pam Greene, and deejays Jessie, Bob Wayne, Del DeMontreux, and Charlie Cook. The other guy with glasses and whiskers—and main competitor to Pat St. John for the title of longest-haired dude in New York radio—is Peter Kanze, WHN's music research coordinator and coauthor of this book.

In this November 27, 1978, photograph, Lou Adler (left) and Jim Donnelly (right) are on the air at WCBS 880 News, working headphone free—a rarity for the radio business then and now. As the golden age of radio started to fade, WCBS would embraced local news gathering in a relatively ambitious manner, starting up the news and talk program *This Is New York* as a lead in to the popular *Arthur Godfrey Time* program, produced by future CBS news president Bill Leonard. But it was only after WINS went all news by the mid-1960s that CBS management decided to make 880 a full-time news station as well. At right is a momento from an explosive New York City summer that was made worse by the citywide blackout of July 13, 1977. Newsradio 1010 WINS stayed on all the way through, serving as a vital conduit for news and information and further proving radio's vital role in emergencies. (Both, courtesy Martin Hardee.)

WINS

THE RADIO STATION THAT GLOWED IN THE DARK

1010 WINS GROUP W
All News. All The Time.

WESTINGHOUSE BROADCASTING COMPANY

REPRESENTED NATIONALLY BY
RADIO ADVERTISING REPRESENTATIVES, INC.

Liz Kiley, hired by program director Rick Sklar in 1979, was the first female deejay to make the grade on WABC. She did not last long but was the first break in a long line of all-male New York Top 40 disc jockeys.

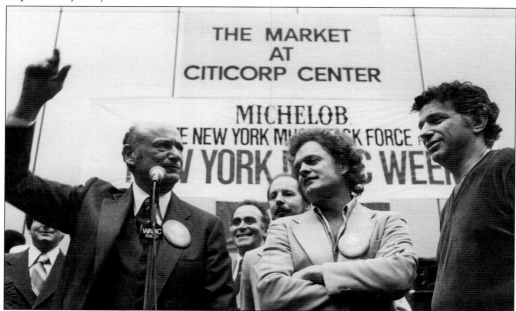

Now *this* is New York radio! Ed Koch, at left, was elected mayor in 1977 at a low ebb in the city's fortunes and is considered by many to be a major reason for the city's turnaround in financial fortune and livability. He also had a knack for radio and was broadcasting a talk show on WBBR Bloomberg Radio up to a week before he died in 2013. Harry Chapin (center), the Long Island–based singer/songwriter of "Cats in the Cradle" and "Taxi" fame, started the World Hunger Year radiothon with the help of his good friend Pete Fornatale. And Dan Ingram is fast, funny, and on the move—a deejay after New York's heart. They are pictured here at the then new Citicorp Center, located at Fifty-third Street and Lexington Avenue.

Pictured is a classic 95.5 lineup. From left to right are Carol Miller, Jim Kerr, Shelli Sonstein, Jimmy Fink, and Tony Pigg. WPLJ's jocks may have had less freedom to play the progressive rock cuts they wanted to during their air shifts than their counterparts at WNEW-FM. The station's playlist was certainly more tightly controlled and more pop- and repetition-friendly than, say, a Vin Scelsa or a Meg Griffin would have been comfortable with. But the payback was enormous: WPLJ was the number one rock station for many years and the sound track for many a suburban teens' high school and college years. As Carol Miller writes in her book *Up All Night*: "Wasn't that why I was there, on the radio, to help people have a good time through the music, and to join in, as a friend? What was all the snobby posturing about?" (Courtesy Jim Kerr.)

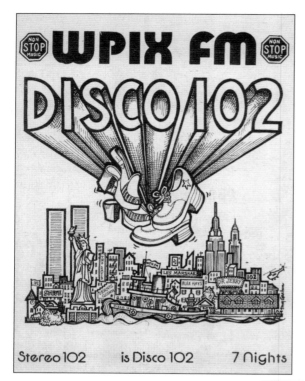

By 1978, disco was unstoppable in New York. It was a massively popular musical genre but also a divisive one; the Top 40 audience that WABC had so expertly cultivated was well on its way towards fragmentation, as many rock fans freely expressed their disgust with the kick drum–heavy, dance-floor-centric music. Less remembered and more short-lived than disco's most legendary outlet WKTU was WPIX's *Disco 102*. Deejay "Dr." Jerry Carroll would go on to be better remembered as a frothing-at-the-mouth pitchman for Crazy Eddie ("his prices are IN-SA-A-A-A-A-ANE!") than as a disco deejay. WPIX always seemed to have trouble settling on a format for long; the station went New Wave in 1979.

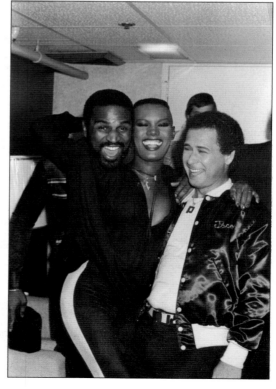

Have no fear . . . Paco is here! WKTU's Manuel "Paquito" Navarro was the undisputed king of New York City radio by 1979, the year disco reached its apex. Pictured here are, from left to right, Ray Simpson (of the Village People), Grace Jones, and Paco. The disco sound was triumphant for a few years, especially resonant in an urban metropolis like New York City, home of the mythical Tony Manero and *Saturday Night Fever*. And with WKTU, for the first time, an FM station would overtake WABC-AM as the city's number one station. The days when a broadly based Top 40–type station could satisfy a majority of New York City's young listening audience were fading fast. (Courtesy Paco Navarro.)

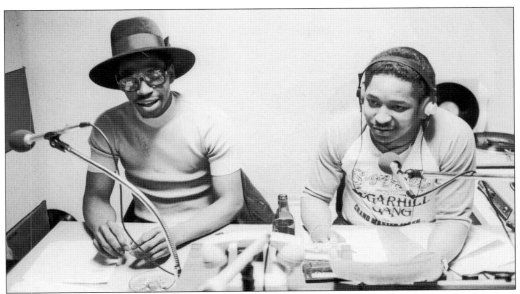

"New York, New York, big city of dreams," rapped Melle Mel, and it certainly *was* a city of dreams for the pioneers of rap music—a sound that New York can certifiably call its own. Two of the most important and essential deejays in rap's history were Mr. Magic (above, right), seen here with Grandmaster Caz (left) broadcasting the breakthrough WHBI-FM program *Rap Attack* in 1981, and his archrival DJ Red Alert, seen below at a WLIB/Air America appearance in 2006. In the mid-1980s, Red Alert could be heard on WRKS (Kiss FM, the former 99X) while Mr. Magic made WBLS his home. The very real rivalry made for great, innovative radio and helped make rap the real "sound of the city" in the latter years of the 20th century. (Both, courtesy Joe Conzo.)

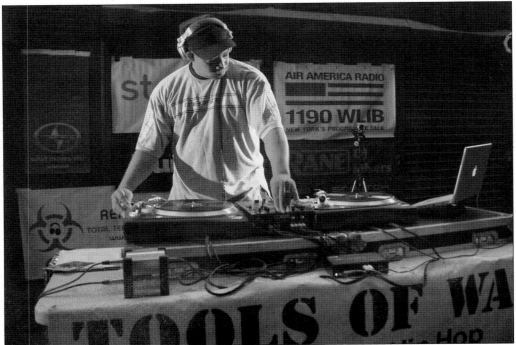

In this image from the 1981 WNEW-FM Calendar are, from left to right, Pete Fornatale, Scott Muni, Dennis Elsas, Dave Herman, Thom Morrera, Pam Merly, Richard Neer, Pete Larkin, and Vin Scelsa. This elaborately posed Wings' *Band On The Run*–inspired pastiche appeared in the first of several elaborately produced calendars that the station's advertising director George Mitchell produced as both a promotional tool and as a fundraiser on behalf of the T.J. Martell Foundation. (Courtesy George Meredith.)

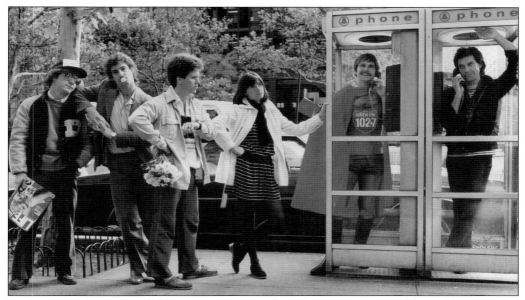

In the image above, from left to right, Jim Monaghan, Dan Neer, Pete Larkin, and Meg Griffin wait with varying levels of patience for "Captain America" (Richard Neer) and head Kink Ray Davies to finish their pay-phone chat. Richard Neer went on to write *FM*, an essential behind-the-scenes account of New York's FM rock radio landscape in the 1970s and 1980s. Below, Scott Muni (left) and Dave Herman (right) pose as Clarence Clemons and Bruce Springsteen, re-creating the inimitable cover shot from the *Born To Run* album. For New York FM-radio rock fans of a certain age, this image just about says it all. (Both, courtesy George Meredith.)

DON'T TAKE ANY SHIRT THIS SUMMER

Insist on the WPLJ ROCKS T-shirt. It is black with white printing and comes in S, M, L, XL. Send a check or money order ONLY for $5.00 to: WPLJ T-shirt, Box 1395, New York, NY 10019. Be sure to include your size(s).

I'm a rocker!
Please send me _____ shirt(s) at $5.00 each in the following size(s): $ _____
M _____ L _____ XL _____
Name _____
Address _____

Return this coupon with your check or money order to: WPLJ T-shirt, Box 1395, New York 10019

WPLJ ROCKS T-SHIRTS ARE ALSO AVAILABLE AT THE RECORD WORLD AND RECORD SHOPS AT TSS STORES.

WPLJ Rocks 95.5

Carol Miller

Monday-Friday 6:00-10:00 PM
Saturday 5:00-10:00 PM

In Carol Miller's autobiography *Up All Night*, she paints a vivid picture of her first impression of WPLJ's star morning man Jim Kerr. She writes that Kerr "had the flaxen long-haired appearance of a midwestern Little Lord Fauntleroy, and the deep voice of an American James Bond." Here, Kerr hosts a rowdy-looking and aptly named "Pale Persons Beach Party" at Sandy Hook, New Jersey, in July 1981.

Carol Miller poses in a "WPLJ Rocks" T-shirt during the station's massively popular heyday. Although Miller worked at the station for only seven years (compared to a later stint at WNEW-FM for 19 years), she notes she is far more remembered for her WPLJ stint by her fans. (Courtesy Carol Miller.)

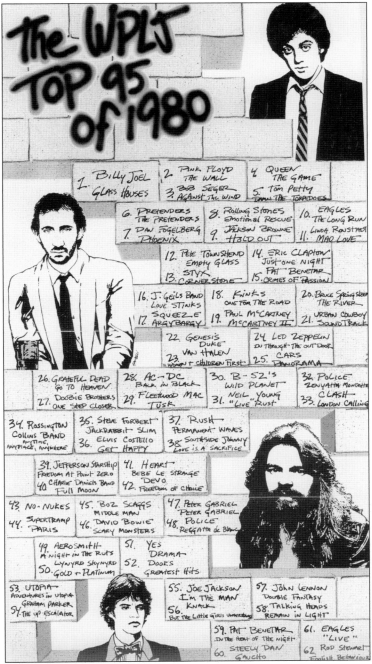

The WPLJ TOP 95 of 1980

1. Billy Joel - Glass Houses
2. Pink Floyd - The Wall
3. Bob Seger - Against The Wind
4. Queen - The Game
5. Tom Petty - Damn The Torpedoes
6. Pretenders - The Pretenders
7. Dan Fogelberg - Phoenix
8. Rolling Stones - Emotional Rescue
9. Jackson Browne - Hold Out
10. Eagles - The Long Run
11. Linda Ronstadt - Mad Love
12. Pete Townshend - Empty Glass
13. Styx - Cornerstone
14. Eric Clapton - Just One Night
15. Pat Benatar - Crimes Of Passion
16. J. Geils Band - Love Stinks
17. Squeeze - Argybargy
18. Kinks - One For The Road
19. Paul McCartney - McCartney II
20. Bruce Springsteen - The River
21. Urban Cowboy - Soundtrack
22. Genesis - Duke
23. Van Halen - Women + Children First
24. Led Zeppelin - In Through The Out Door
25. Cars - Panorama
26. Grateful Dead - Go To Heaven
27. Doobie Brothers - One Step Closer
28. AC~DC - Back In Black
29. Fleetwood Mac - Tusk
30. B-52's - Wild Planet
31. Neil Young - "Live" Rust
32. Police - Zenyatta Mondatta
33. Clash - London Calling
34. Rossington Collins Band - Anytime, Anyplace, Anywhere
35. Steve Forbert - Jackrabbit Slim
36. Elvis Costello - Get Happy
37. Rush - Permanent Waves
38. Southside Johnny - Love Is A Sacrifice
39. Jefferson Starship - Freedom At Point Zero
40. Charlie Daniels Band - Full Moon
41. Heart - Bebe Le Strange
42. Devo - Freedom Of Choice
43. No-Nukes
44. Supertramp - Paris
45. Boz Scaggs - Middle Man
46. David Bowie - Scary Monsters
47. Peter Gabriel - Peter Gabriel
48. Police - Reggatta de Blanc
49. Aerosmith - A Night In The Ruts
50. Lynyrd Skynyrd - Gold + Platinum
51. Yes - Drama
52. Doors - Greatest Hits
53. Utopia - Adventures in Utopia
54. Graham Parker - The Up Escalator
55. Joe Jackson - I'm The Man
56. Knack - But The Little Girls Understand
57. John Lennon - Double Fantasy
58. Talking Heads - Remain In Light
59. Pat Benatar - In The Heat Of The Night
60. Steely Dan - Gaucho
61. Eagles - "Live"
62. Rod Stewart - Foolish Behaviour

Here is a fascinating look at New York's AOR (album oriented rock) music scene at the beginning of the 1980s, pre-MTV and before the concept of "classic rock" had solidified. New Wave acts made impressive inroads into the mainstream, especially those of the more melodic persuasion (The Pretenders, Squeeze, The Police). But aging rockers like Pink Floyd, The Grateful Dead, and Led Zeppelin obviously still have a strong hold on fan loyalties. And Long Island's own Billy Joel? Well, he reigns supreme.

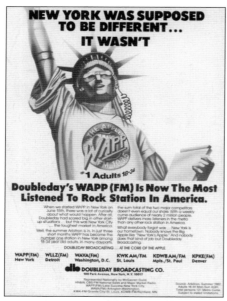

In the summer of 1982, easy-listening WTFM was bought by Doubleday Broadcasting. It was quickly flipped to an AOR format as WAPP, kicking off with a well-remembered commercial-free summer. Not too surprisingly, the station shot up to No. 1; also not too surprisingly, the station quickly saw its high ratings fade as advertising was added into the mix by the fall. The station later switched to a CHR (contemporary hits radio) format in the fall of 1984 but would did not survive its battle with an unstoppable Z100.

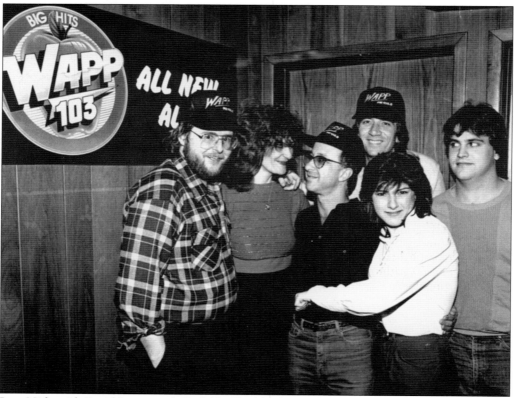

Late Night with David Letterman's Paul Shaffer (third from left) pals around with WAPP's staff, from left to right, Harry Nelson, Jane Dornacker, Gerry Cagle, Lynette Abraham, and Steve Ellis. Dornacker, an actress and comedienne originally from San Francisco, soon went on to work for WNBC and, sadly, did not survive an on-air traffic helicopter accident in 1986.

The Z100 Morning Zoo in the mid-1980s consisted of, from left to right, Ross Brittain (a refugee from WABC), John Bell (WVNJ's community affairs director), Claire Stevens, and Scott Shannon. Shannon, a tireless radio fanatic, had come to New York after developing the "morning zoo" concept at Tampa's WRBQ and launched WHTZ—an updated MTV-era attempt at a Tope 40–formatted station—in August 1983 from the ashes of New Jersey's easy-listening stalwart WVNJ-FM. The "Zoo," a scrappy, contest-filled, and outrageous (but not *too* outrageous) morning show, was a major reason Z100, within 74 days of signing on, went from worst to first in New York's Arbitron Fall 1983 ratings book. (Courtesy Scott Shannon.)

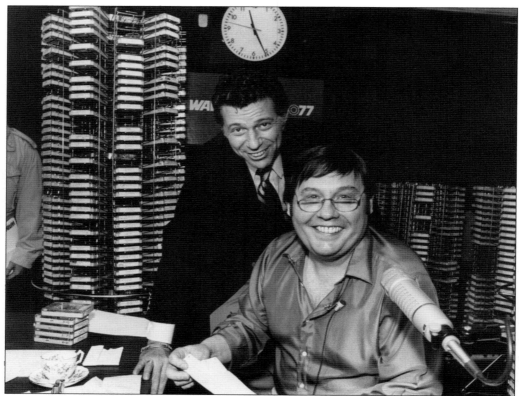

For WABC, May 10, 1982, was "The Day The Music Died." The station wrapped its 22-year run as a Top 40 music powerhouse with a nostalgic 9:00 a.m.–12:00 noon show cohosted by Dan Ingram and Ron Lundy. The station then switched to an all-talk format, which it maintains to this day. Below, Ingram and Lundy are happily reunited at WCBS-FM, the city's beloved "oldies" station, where so many of WABC's classic deejays found new on-air homes.

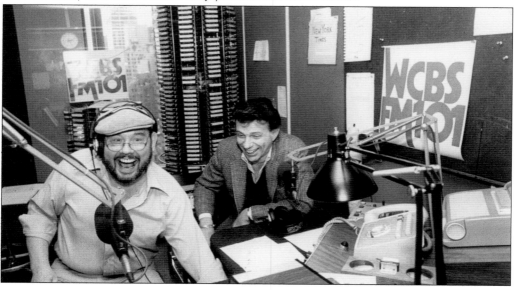

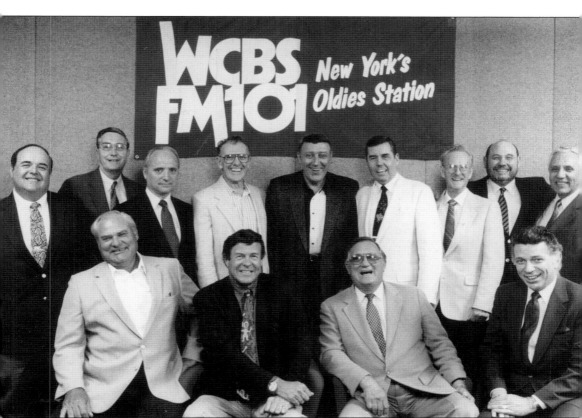

WCBS-FM, smartly programmed for its New York City audience by ex-WOR-FM deejay Joe McCoy, was New York's well-loved home of oldies and, not coincidentally, the city's hangout for the all-time all-stars of Top 40 radio. The station began airing its "Rock & Roll Radio Greats" weekends starting in 1984; this lineup was from the early 1990s. Pictured from left to right are (seated) Herb Oscar Anderson, "Cousin" Bruce Morrow, Ted Brown, and Dan Ingram; (standing) Ed Baer, Bill Beamish, Frank Stickle, Joe O'Brien, Jack Spector, Harry Harrison, Charlie Greer, Ron Lundy, and Dean Anthony.

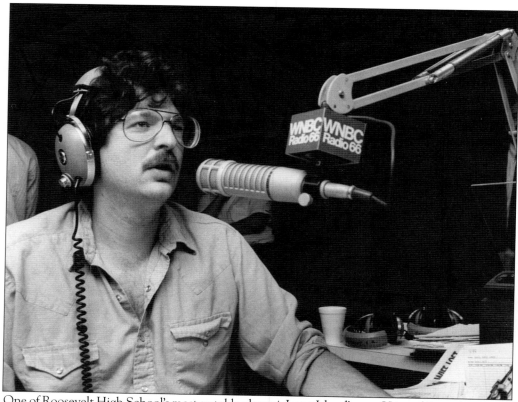

One of Roosevelt High School's most notable alumni, Long Island's own Howard Stern is pictured above in 1982, shortly after he arrived at WNBC from Washington, DC's WWDC. Below, "How-weird" (laying on the ground) and various aerobics instructors pose in front of the second floor 30 Rock elevator bank in 1983. (Above, courtesy NBC.)

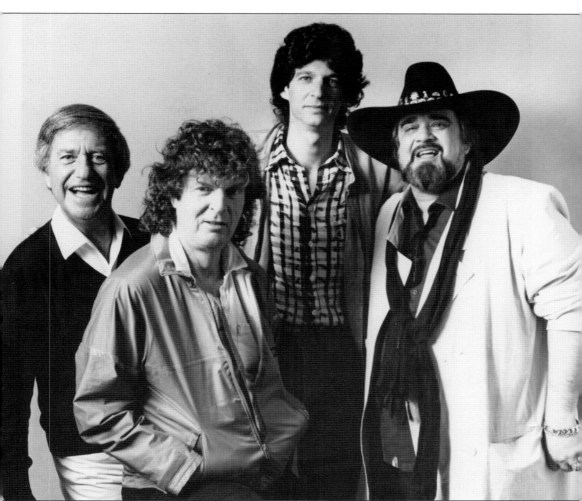

It is 1985, spring is in the air, and Soupy Sales, Don Imus, Howard Stern, and Wolfman Jack are together at WNBC-AM. But not for long. Stern would be fired by the fall. Howard's controversial travails at W-NNNNNN-BC are well documented in his 1993 book and 1997 movie *Private Parts*; Howard would soon start things up again at WXRK 92.3 KRock, where he became the morning ratings leader in the city—and eventually a syndicated "King of All Media" for the entire country. Love him or hate him, Howard Stern is unquestionably one of the smartest, most successful, and most innovative broadcasters of the modern era. He and his staff (including Robin Quivers, Fred Norris, and Gary "Baba Booey" Dell'Abate) create a loose and outspoken atmosphere, not unlike that of a high school cafeteria table where friends make fun of each other and everyone else by saying increasingly loud and "shocking" things. (Courtesy NBC.)

Bob Grant, a New York original, was a major innovator of right-wing radio—the salvation of the AM radio band. (Courtesy Library of American Broadcasting.)

Rush Limbaugh interviews presidential candidate George H.W. Bush in 1988, Limbaugh's first year at WABC. Limbaugh might not seem like a New York radio guy at first glance; after all, he got his start as Top 40 jock "Jeff Christie" in Pennsylvania, developed his right-wing comedy-attack shtick in Sacramento, and has been doing his show from Tampa for many years now. But Limbaugh, like many ambitious radio talents, had to come to New York to make his name and was invited by former ABC Radio president Edward F. McLaughlin to settle in at WABC. He went national by the fall of 1988, and love him or loathe him, Limbaugh undeniably became one of the biggest radio personalities of all time. (Courtesy Library of American Broadcasting.)

Five

LIVE FROM NEW YORK

Seen here is WKCR's Phil Schaap, the city's keeper of the flame for classic jazz. Phil was most likely the only Little Leaguer in late-1950s Hollis, Queens that routinely rushed out to his parents' car in between innings in order to tune in the latest in big-city jazz music. New York City had a long line of impressive and influential jazz deejays—Symphony Sid (WMCA, WHOM, WJZ), WEVD's Mort Fega, WQXR's John S. Wilson, and WRVR's Ed Beach, to name a few—and Phil is carrying on in their tradition, working now for over 40 years on a volunteer basis (as he always has) at Columbia University's FM station. His show *Bird Flight*, started in 1981, goes into so much obsessive detail over the music of Charlie Parker and others that the *New Yorker*'s David Remnick claimed that "Schaap frequently sounds like a mad Talmudic scholar who has decided that the laws of humankind reside not in the ancient Babylonian tractates but in alternate takes of 'Moose the Mooche' and 'Swedish Schnapps.' " (Photograph by J.R. Rost.)

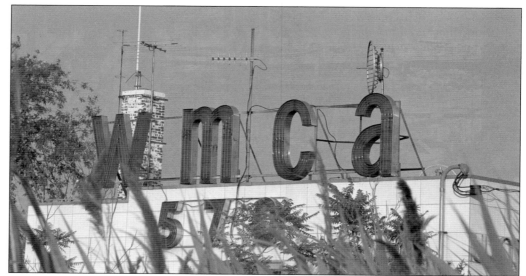

WMCA's transmitter site—here looking almost overgrown with weeds—is based in the New Jersey Meadowlands, just north of the Pulaski Skyway in Newark. The station switched to a Christian radio format in 1989. (Courtesy Jim Hawkins.)

It is 10:00 a.m. on Monday June 19, 1989, and the *New York Times*' classical station WQXR is switching over its program feed from its old studios in the Times Building to brand-new studios at 122 Fifth Avenue. From left to right are program director Loren Toolajian, midday host Steve Sullivan, chief engineer Herb Squire, president and general manager Warren Bodow, and Alfred D'Alessio, the studio designer.

Stan Martin, Tony Bennett, and Jonathan Schwartz are pictured here, from left to right, on December 2, 1992. WNEW-AM, a couple of weeks away from passing into history, had been sold to future mayor Michael Bloomberg's media conglomerate and was about to be relaunched as the business news-oriented WBBR. But a new station named WQEW, on the frequency formerly dedicated to WQXR-AM, was picking up the baton and launched on this day as New York's new home for "classic American pop"; WNEW-AM's legacy would live on for at least a few years more. The first three songs heard on WQEW were Frank Sinatra's "New York New York," Nat King Cole's "Stardust," and Tony Bennett's "The Best Is Yet To Come." (Courtesy Library of American Broadcasting.)

Danny Stiles (also known as "the Vicar Of Vintage," or "Stiles on your Dials") passed away in 2011; yet his relentlessly cheerful voice and his priceless, immensely deep collection of American pop records from the 1920s through the 1950s can still heard, as of this writing, loud and clear on WNYC-AM's airwaves on Saturday nights. He may not have always worked for the highest visibility stations, and his presentation may not have been the fastest paced, but there was perhaps never a New York broadcaster with more of an obvious love for his audience, more of an encyclopedic knowledge of his music, and such an obvious, sheer joy in his medium of choice than Stiles. (Courtesy Mark Buniak.)

Scott Shannon and Tod Pettengill are seen here on their first day broadcasting WPLJ's *Scott and Todd in the Morning* in 1991. Shannon, after his spectacularly successful launch of Z100, left New York for Los Angeles in 1989 to head up Pirate Radio KQLZ but returned to the Big Apple two years later to help out the moribund WPLJ, which had fallen far down in the ratings from its early 1980s heyday. Shannon and Pettengill originally tried to compete directly with Z100 but then moved the show, and the station itself, into more of an "adult contemporary" direction, which has made WPLJ a steady (if unspectacular) success for over 20 years. The suburban-soccer-mom-friendly station consistently out bills other New York stations, even ones with higher ratings. Scott's love and understanding of the radio business and its audience continues unabated. (Courtesy Scott Shannon.)

Above is Valerie Smaldone at WLTW, New York's Lite FM, the city's low-key but dominant adult contemporary music station for the last few decades and—in many respects, especially in its earlier years—the modern-day equivalent of the "easy listening" stations of the 1950s and 1960s. Although the station's playlist has evolved from the "soft rock" heard at its January 1984 launch, Lite FM is still designed to be non-offensive at its core, an ideal station for office listening. (It also plays nothing but Christmas music after Thanksgiving and through the end of the year.) Valerie was let go by WLTW in 2008 but, like many a hardworking New York deejay, has a strong career as a successful voice-over artist, as seen at right. (Above, courtesy Scott Fybush; right, courtesy Valerie Smaldone.)

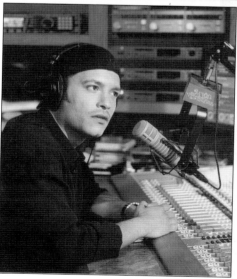

When Howard Stern left the world of terrestrial radio for satellite in 2006, a new number one New York City morning show emerged—this one taking many by surprise. Luis Jiménez and his sidekick Ramón "Moonshadow" Broussard dominated the city's growing and upwardly mobile Hispanic audience with their own brand of outrageous (and often political) radio humor on WSKQ's *El Vacilón de la Mañana* show, which debuted in 1993. Like Stern, little was taboo; also like Stern, they capitalized on their massive popularity by making a movie. Due to a salary dispute, Jiménez left WSKQ after the movie's release, then returned to the New York airwaves on Univision's WXNY (X96.3 Es Música en VIVO), where he continues his tradition of controversial, boundary-crossing radio. (Both, courtesy Alma Entertainment LLC.)

After two decades of being the city's dominant radio personality and $2.5 million in fines from the FCC, "King Of All Media" Howard Stern decided to move his show to subscriber-based, uncensored Sirius Satellite radio in 2006. The move was financially successful, but it also served to lower Howard's visibility in America's pop culture firmament, which probably influenced him taking his current role as a judge on NBC's *America's Got Talent*. (Courtesy Library of American Broadcasting.)

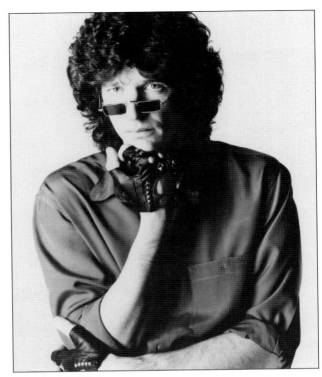

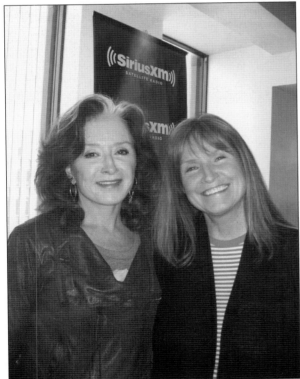

The uncompromising Meg Griffin, whose on-air sparring/flirting with Howard Stern made for great radio in the K-Rock days, also found a home on satellite radio. Initially heading up the free-form Sirius Disorder channel, and more recently on The Loft, Classic Rewind, and Deep Tracks, "Megless"—seen here with Bonnie Raitt in 2012 at Sirius's Rockefeller Center studios—continues, against the odds, to play and champion the music she most wants to hear.

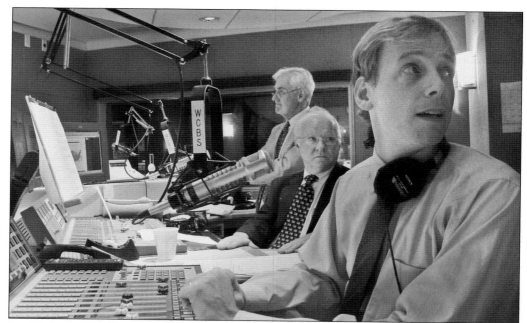

In this photograph from election night 2000, Maurice Carroll from the Quinnipiac Polling Institute stands as WCBS's Rich Lamb (center) and Wayne Cabot (right) take the evening's events in. The station's studios were still on the 16th floor of "Black Rock," CBS's Eero Saarinen–designed headquarters on Fifty-Second Street and Sixth Avenue at the time. "That expression on our faces," says Cabot today, "meant 'Whaddya mean, Al Gore is NOT the winner?' "(Courtesy WCBS.)

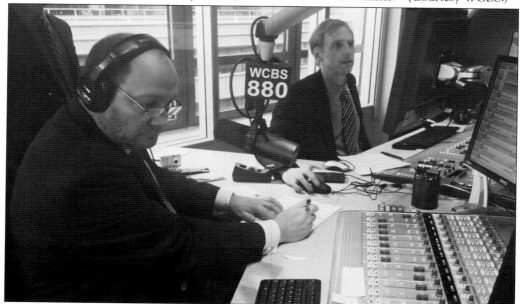

On day one at WCBS-AM's new studios at 345 Hudson Street, December 11, 2011, Steve Scott and Wayne Cabot get used to the new setup. CBS Radio moved several of its New York stations (WCBS-FM, WINS, WFAN, WWFS, and WXRK) to the new high-tech complex around the same time. (Courtesy Wayne Cabot.)

Three of the New York's most legendary, beloved, and hardworking radio newscasters happily pose together at Mayor Bloomberg's 2006 inauguration. From left to right are Rich Lamb (WCBS), Stan Brooks (WINS), and Mitch Lebe (WBBR). Combined broadcasting experience in this picture equals approximately 110 years. (Courtesy Mitch Lebe and Bob Gibson.)

This is a fascinating, close-up look at the legendary "sounder" buttons that the announcers at WCBS hit several times an hour, alerting listeners (in a sort of Pavlovian, subliminal way) "that here comes a traffic report, or some sports news, or a weather alert, and it is *time* to pay *attention!*"

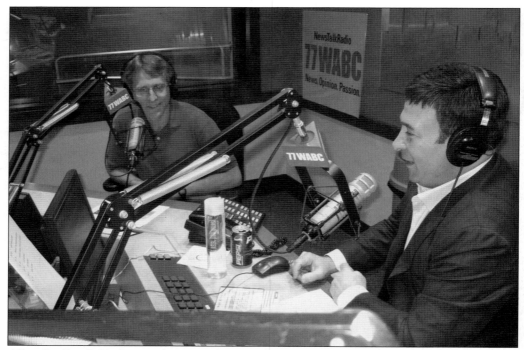

Allan Sniffen (left) chats with WABC host Mark Simone (right) in 2006 about the glory days of Top 40, during that year's annual "Rewound" Labor Day weekend marathon. Sniffen, a Westchester County–based dentist with a lifelong love of radio, first started his WABC Musicradio 77 tribute website in 1997, alongside his New York radio message board. Both sites are essential for true fans of the legacy of New York radio. Out of the community of fans and professionals came the idea to create a tribute to the city's most legendary to Top 40 station, WABC, using air checks recorded over the years mixed in with the actual songs played in those actual air checks. From 1999 through 2009, WABC put aside its talk-radio format on Labor Day weekends to celebrate its classic sound, thanks to the efforts of Sniffen, producer Johnny Donovan, and assistant producer Peter Kanze. More recently, Sniffen (whose love of classic Top 40 radio continues unabated) has created the Top 40 oldies station of his dreams, Rewound Radio, as a labor of love. (Courtesy Allan Sniffen.)

Bernie Wagenblast smiles for the camera in between announcing for 1010 WINS and New Jersey 101.5 (WKXW) at the Total Traffic (previously Shadow Traffic) studios in Rutherford, New Jersey. Wagenblast once went by the pseudonym "Jack Packard" back when he served as Dan Ingram's first-ever traffic reporter at WABC. Note the television monitor image of the George Washington Bridge behind the microphone. (Courtesy Bernie Wagenblast.)

In late 1986, NPR journalist and music historian Felix Hernandez was asked by WBGO's program director, Wylie Rollins, to do a show about classic soul and rhythm-and-blues music; Felix accepted the challenge and decided to name his new show after a phrase from Chuck Berry's "Roll Over Beethoven." Since then, *Rhythm Revue* has been a home for lovingly curated, rarely heard, and uproariously great rhythm and soul records, the kind you would hear on WOV, WWRL, and WNJR if you had been hip enough to listen back in the day. The show is now in its 26th consecutive year on New York radio and has also found homes at KISS-FM, Jammin' 105, and WBLS at various times over the years. Felix also continues his fun and live Rhythm Revue dance parties (often held at the classic Roseland Ballroom on Fifty-fourth Street), where New Yorkers of all ages and races dance the boogaloo long into the night. (Courtesy *New York Daily News*.)

Their lives were saved by rock and roll. Two icons of New York City rock—Vin Scelsa (left) and Lou Reed—pose inside WFUV-FM's music library. Fordham University's station continues to thrive as a listener-supported bastion of the "Triple-A" (adult album alternative) format and as a home for some of the city's most beloved and iconic broadcasters, including Dennis Elsas, Rich Conaty, and Rita Houston. (Courtesy WFUV.)

WPLJ alumni, still rocking! Shelli Sonstein (left) and Jim Kerr (right, cohosts of Q1043's *Rock & Roll Morning Show*) pose with fellow WAXQ deejay Carol Miller, who is holding her 2012 tell-all, life-in-New-York-radio autobiography *Up All Night*. It is interesting to note that Q104.3's studios, part of Clear Channel's ultramodern studio complex at 32 Sixth Avenue, is located in the building once known as AT&T's Long Lines Building, where the NBC radio network first went live from across the nation. (Courtesy WAXQ.)

Ricot Dupuy of Brooklyn's Radio Soleil broadcast in the Haitian Creole dialect for over 20 years on a subcarrier frequency of WSKQ, carrying on the fine and important tradition of Brooklyn's ethnic- and community-based radio stations. His loyal audience has traditionally listened to his station on specially purchased subcarrier-ready radios but now more frequently hear him via the Internet, both in New York and in Haiti itself. After the 2010 Haitian earthquake, Dupuy stayed on the air for days, relaying vital information between the devastated island and the Haitian community in New York, desperate for news. Radio Soleil is a strong indicator that New York City's radio scene is far from dead. There will always be a need for smartly produced audio information and entertainment that speaks to specific audiences within the demographically diverse communities of the "gorgeous mosaic" of New York City. (Photograph by Mick Cantarella.)

It seems inevitable that broadcast radio will evolve into only one of several potential methods for distributing audio information and entertainment in the future. Meanwhile, Internet-only radio stations have proliferated; anyone can start one, and sometimes it seems like everyone has. But East Village Radio may be on to something. Their storefront studio on First Avenue, between First and Second Streets in Manhattan's trendy East Village, has given EVR a tremendous presence in the community. Deejays are seen spinning discs and chatting to a worldwide audience day and night; often, curious passersby are called into the studio to join in on the fun. Pictured here is deejay/comedian Jonathan Sollis jockeying the discs. Perhaps the future of New York City radio is right here—at a station with strong, visible community ties and an ability to move quickly and inexpensively with rapidly changing times. Tune in tomorrow, New Yorkers! (Both, photograph by Mick Cantarella.)

SELECTED BIBLIOGRAPHY

Barnouw, Erik. *A Tower In Babel: A History of Broadcasting in the United States, Volume I*. New York: Oxford University Press, 1966.

Fisher, Marc. *Something In The Air*. New York: Random House, 2007.

Halberstam, David J. *Sports on New York Radio: A Play-By-Play History*. Chicago: Masters Press, 1999.

Jaker, Bill, Frank Julek, and Peter Kanze. *The Airwaves of New York: Illustrated Histories of 156 AM Stations in the Metropolitan Area, 1921–1996*. Jefferson, NC: McFarland & Company, 1998.

Neer, Richard. *FM: The Rise and Fall of Rock Radio*. New York: Villard Books, 2001.

Passman, Arnold. *The Deejays*. New York: Macmillan, 1971.

Settel, Irving. *A Pictorial History of Radio*. New York: Grosset & Dunlap, 1967.

Sklar, Rick. *Rocking America*. New York: St. Martin's Press, 1984.

FOR FURTHER READING (AND LISTENING!)

Musicradio 77 WABC, musicradio77.com

New York Broadcasting History Board, musicradio77.com/historyboard/wwwboard

New York Radio Archive, nyradioarchive.com

New York Radio Guide: Where New Yorkers Turn On and Tune In, nyradioguide.com

History of American Broadcasting, jeff560.tripod.com/broadcasting.html

Pirate Jim's NYC, NJ and Philly AM & FM History Pages, Radio-History.com

Reelradio's Reel Top 40 Radio Repository, reelradio.com

WCBS All-News 88 Appreciation Site, donswaim.com/wcbsnewsradio88.html

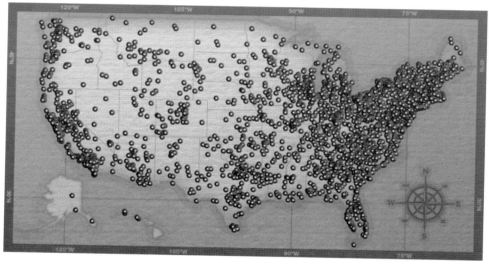